Writer and artist ILYA has been [a] comics creator, author and educ[ator for] years. Since 1990 he has designe[d] on the art of drawing for school[s,] museums, libraries, youth group[s and prisons across the UK] as well as abroad. His *Manga Drawing Kit* has been published in four languages and is an international bestseller. Other books by ILYA include the award-winning graphic novel series *The End of the Century Club*, Manga Shakespeare's *King Lear* and *Room for Love*. He is also the compiling editor for *The Mammoth Books of Skulls*, *The Mammoth Book of Cult Comics*, three volumes of *The Mammoth Book of Best New Manga* and *Colour Me Bad*. In 2017, he produced the sci-fi action adventure *Kid Savage* in collaboration with Joe Kelly (co-creator of *Ben10*).

HAPPY
BIRTHDAY
JAMES

from ILYA!

Also by ILYA

HOW TO DRAW
ABSOLUTELY
ANYTHING
ACTIVITY BOOK

First published in Great Britain in 2018 by Robinson

13 5 7 9 10 8 6 4 2

A CIP catalogue record for this book is available
from the British Library.

ISBN 978-1-47214-073-9

Typeset in Cambria & Calibri
Printed and bound in Great Britain by CPI Group (UK) Ltd, Croydon CR0 4YY

Papers used by Robinson are from well-managed forests
and other responsible sources.

Robinson
An imprint of
Little, Brown Book Group
Carmelite House
50 Victoria Embankment
London EC4Y 0DZ

An Hachette UK Company
www.hachette.co.uk

www.littlebrown.co.uk

CONTENTS

INTRODUCTION

CAN DO DRAWING

Ask a person to draw, and nine times out of ten their immediate response will be:

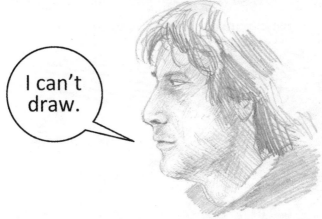

When people say this, it does not mean that they cannot draw. Anybody can draw.

What they mean and what they are really saying is:

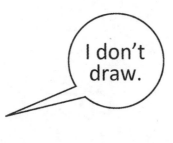

There's a BIG difference.

There's no secret to drawing.

Put pen or pencil to paper, or, increasingly, stylus or even your finger to a touch-sensitive screen, and make a mark – any mark – and you are drawing.

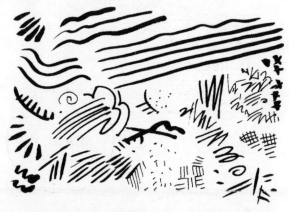

Make a mark. *Do* draw. You CAN draw.

YOU can draw. Anybody can draw.

What comes into play after that is a critical internal voice that says:

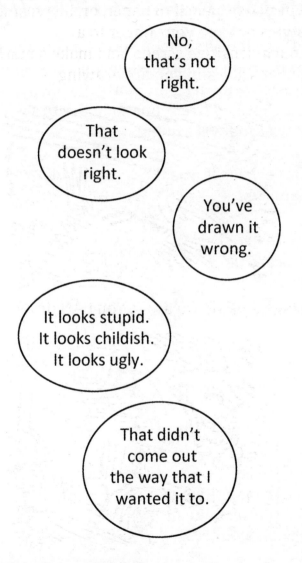

No, that's not right.

That doesn't look right.

You've drawn it wrong.

It looks stupid. It looks childish. It looks ugly.

That didn't come out the way that I wanted it to.

And so on and so forth.

Ha ha Haha

Maybe it was someone else's discouraging or derisive laughter when you once showed them a drawing – or, more than likely, when they peeked over your shoulder to see what it was you were doing.

Or perhaps it was the careless relative who said:

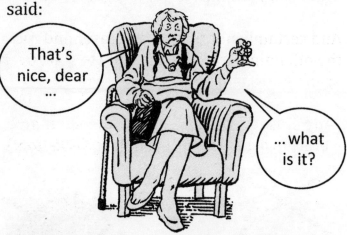

That's nice, dear ...

... what is it?

But, just as easily, it could be your own:
- ☐ doubts
- ☐ fears
- ☐ competitive nature
- ☐ perfectionism

that's talking. *(Tick as appropriate.)*

Do you hear voices?

Do you hear voices? You do. ~~Then you are possessed.~~ We all do. The important thing here is not necessarily to ignore them, so much as not to let them deter you or hold you back – from drawing, or anything else.

Instead, use them to spur you on, to make you move on, to make you draw MORE.

NOT to do the same drawing over and over again in an attempt to get it 'right' ...

And certainly not to grab an eraser and rub the offending drawing out. Only to start over again. And again.

(Any erasers you have, throw them out now – erasers are BANNED! ... In fact: BINS, too!)

Hear the voices, but don't let them stop you.

Instead, move on to the *next* drawing.
Do that drawing. And then the *next*. And the next one after that.

Ideally, with each and every drawing that you do, you will get better – better at drawing, or perhaps simply better at ignoring the negative whispers, better at accepting the drawings as they come out – which is to say: Growing in Confidence.

No,
that's not right.

That doesn't look right.

You've drawn it wrong.

It looks stupid. It looks childish. It looks ugly.

The voices don't go away.
They will always be there.
Simply put, you stop listening.
You get out of your own way.

You draw, you draw, and then you draw some more.

You can draw. Anybody can draw.
So long as you want to draw, and DO draw, then the more that you draw the better you will get at doing it.

So, what are you waiting for?

Activity: Pick up the nearest pen, or pencil, or felt tip, whatever is at hand. Pick it up right now and begin to make some marks with it. Go on.

Do it right here on the page. Marks. Anything.

Did you do it? Be honest. If you didn't, STOP right now. Go back. Grab that mark-maker. MAKE. SOME. MARKS. This isn't called an 'Activity Book' for nothing, y'all!

☐ Done?

OK, so ...
☐ Did you have to stop and go looking for something to draw with?

☐ Do you have some more paper and drawing equipment immediately to hand?

☑ Have you found a surface that's easy to work on?

If NOT, if your answers were:

☐ Yes/No,
☐ Yes,
☐ No, and
☐ No

(keep up!)

... then there are already some things that you need to put right straight away ...

OBJECT LESSON

Always make sure you have the TOOLS around *ready* to work with, to make your marks with – around or readily available.

If that seems untidy to you, or else the pens and papers keep getting tidied away, then have a place where they belong that you can easily access whenever you want to.

This counts as well when you are out and about.

Pockets. PENS often have clips on them, for keeping them in pockets. It's meant to be. PENCILS? Not so much. Well, in that case – a wee pencil case that you can carry about. Or a certain slot in your handbag or manbag.

What about PAPER? Always have a few scraps handy (replaced whenever used up). A small SKETCHBOOK or NOTEBOOK – in fact, a number of them scattered around the place, as well as one on your person, ideally. The back of an envelope, or a till receipt, or the blank space in any old newspaper or magazine advert will do, at a pinch.

Failing all of that, how smart is your phone?

Make your readiness to draw into a HABIT.

If you can make it your habit to draw – and what's more, to be willing and able to draw at any particular moment, day or night, no matter where you are – then you're more than halfway to achieving the ability to draw. *Your* ability to draw.

DRAW EVERY DAY and your drawing WILL improve.

It's like playing the harp, or riding a bicycle (or harp-playing *while* riding a bike!). **Below**: *Corinne*, after Elisabeth Louise Vigée Le Brun.

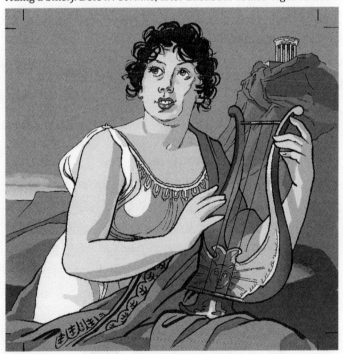

There's nothing to stop you, but you.

1. HOW TO DRAW

HOW TO DRAW?

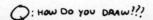

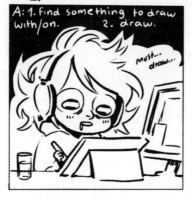

THE ANSWER IS SIMPLE:
JUST DRAW!

Above: *tapas.io/series/Fail-by-Error*
by Min E. Christensen, art blog: www.yesartstumblr.com

DRAWING TOOLS

No, not claw hammers, wrenches and so on. We properly begin by taking a look at your drawing equipment – finding, and using, the possible tools that you will draw with.

TIME TO GO SHOPPING
Your local art materials store should carry the widest and best quality range. If there's not one in your area, then many of the larger supermarket chains have an arts and crafts section. You may also find useful drawing materials located within various superstore departments, from office supplies and stationery through to hardware; at speciality trade/branded stores; or else via the usual online stockists.

TRY BEFORE YOU BUY

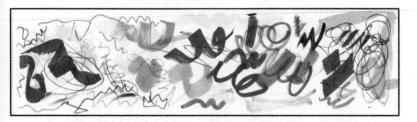

In most art shops you should be able to try out the various mark-making products, by using the small scribble pads provided.

Make these scribble pads your friend – art materials can be especially expensive, so it's worth taking the time and trouble to test the different products before purchase.

DIFFERENT FOLKS, DIFFERENT STROKES

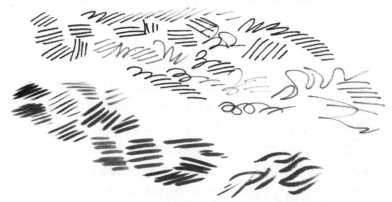

When it comes to drawing equipment, there is no 'one size fits all'. We're each and every one different.

The character of any drawing partly relies on **hand to eye coordination**, which may be learnt, and improved, yet remains very much unique to the individual.

It also depends on the natural **speed** at which a person draws – some move fast, some faster still, while others go s-l-o-w-l-y.

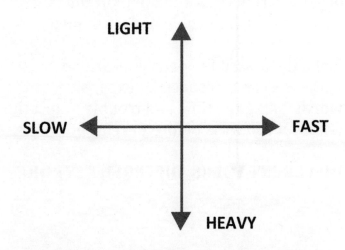

As well, there are the variable degrees of **pressure** applied. Some people have a feather-light touch. Others are distinctly heavy-handed. There's no right or wrong about this. It depends on many factors – inclination, preference, personality, mood – and these can be taken in almost any combination. It can even come down to what it is that you have chosen to draw.

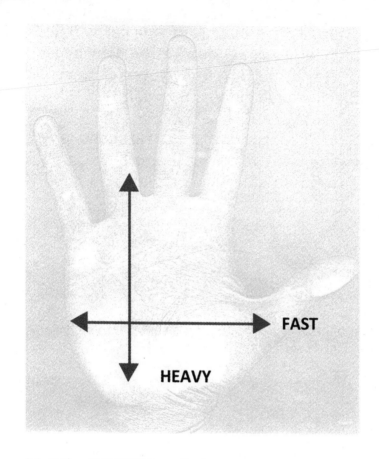

Me? I'm HEAVY-handed.

And my hand moves FAST.

That is how I draw.

This affects not only my drawings, but also my choices when it comes to what equipment I draw with.

Starting out, I recommend that you TRY
EVERYTHING. Your hand speed and pressure
may be different. It may develop over time.
In any case, it will be very much your own.

Find out by trial and error what works best
for *you*.

MAKING YOUR MARKS

It is well worth becoming familiar with the huge range and wide variety of drawing materials at your disposal. And the best way to do this is to get down and dirty with them.

PENCILS

So-called 'lead' pencils are made of a mix of clay with water, known as *graphite*. (If they actually were made of lead metal, they would slowly poison and kill us!)

The most ordinary pencils come in a range of densities, from H (for Hardness) through B (for Blackness). Thus the designation HB – for the mid-range, average-quality pencil – stands for Hard Black. Ain't it sexy?

H, 2H, 3H, 4H

H pencils are fairly unforgiving. The line that they give is relatively precise, but it can seem light, or 'faint'.

(I've had to boost the contrast of this image – made with a **4H** pencil – in the computer, to make it show up enough for you to see it.)

HB is the most common pencil and works for pretty much anything – an average performer perhaps, but always dependable.

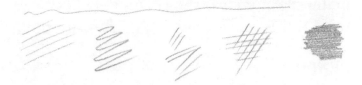

You can't go too far wrong either way with an H, B, 2H or 2B – still, everyone finds their favourites according to their needs.

However, by the time you get on to the thoroughbreds, you will start to experience some starry or diva-like behaviour.

A soft pencil like the **4B**, seen below, can wear down unevenly. This begins to produce variable strokes.

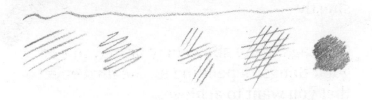

Now, bear in mind, variable strokes may be what you want, depending on your emerging style or the kind of drawing you want to do.

By the time you get to an **8B**, you may find it picking up the 'grain' or surface texture of the paper that you are drawing on.

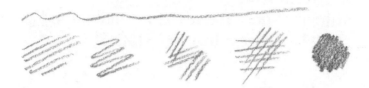

The finish is waxy, and may need 'fixing', or else it will smudge with rubbing or handling.

GRAIN?? FIXING???
More about both of these things
shortly.

Once again, the above may or may not be good things, depending on the final effect that you want to achieve.

This is where experimentation pays off – where individual variations in style and technique, any artist's signature, come from.

HARD BLACK

As well as from Hard (H) to Black (B),
ordinary pencil range can be understood as
going by degrees from HARD to SOFT.

HARD SOFT

Similarly, from LIGHT to DARK.

LIGHT DARK

A HARD pencil gives a relativity LIGHT line
– the harder it is, the lighter the line.

A SOFT pencil will give you a gradually
darker line. The harder you press down, the
more graphite is applied, the more DARK
and thick the marks become.

Dealing for the moment in these broadest of generalisations, you may find the following helpful:

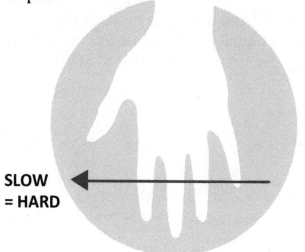

SLOW
= HARD

A HARD pencil will most likely be best suited to a SLOW hand.

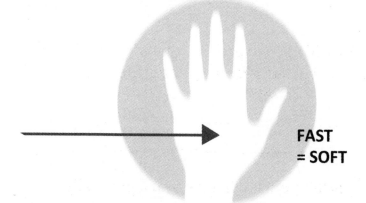

FAST
= SOFT

If your hand moves quite FAST, a SOFTER pencil will usually yield better results.

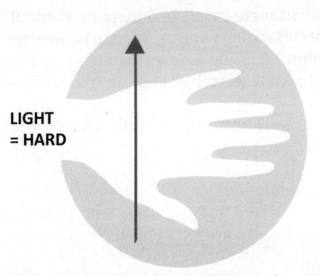

LIGHT = HARD

When you draw with a LIGHT touch, a HARD pencil works best.

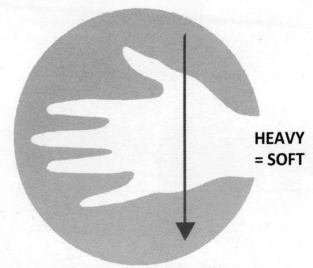

HEAVY = SOFT

And a SOFT pencil is better suited to a HEAVY hand.

Your ultimate choice of drawing tool should reflect the speed and pressure of your hand motion – bearing in mind the effects that you might want, as well as your natural tendency.

It's already been suggested that a soft pencil better suits a heavy hand.

But perhaps not *too* soft, since the heavier you press, the more graphite you apply – and if you are not careful you could soon end up with a smudgy mess (smears across the paper, through your drawing, and all over your hands as well).

If you tend to press down hard, then a hard pencil may carve deep ruts into the paper's surface, or even the table beneath. (I'm so heavy-handed that I used to do this, before I learnt what suited me better!)

If you then start shading, these same ruts will show up as ghostly gaps.

And yet, on another fine day – these sorts of accidents may well prove themselves to be useful for special effects.

On the flipside, it might also be said that coming to understand your level of hand to eye coordination, whether FAST, SLOW, HEAVY and/or LIGHT – and then, how best to cater to it – should only dictate your first or favourite choice of drawing tool.

4H
3H
2H
H

HB

B
2B
3B
4B
5B
6B

With practice and dedication, you can learn to vary the SPEED and PRESSURE applied, going beyond what comes naturally to develop different levels of coordination – and, thereby, opening up yourself and your art to the widest array of possible outcomes.

Development of this skill is your *versatility*.

OTHER TYPES OF PENCIL

Technical pencils, also known as 'mechanical' or 'push pencils', house a graphite filament renewed with every click.

They render a precise and steady point, with no need for sharpening. Even these replaceable filaments eventually run down of course, but, loaded a bunch at a time, they make the refillable pencil 'everlasting'.

Since their line weight is so consistent, they are best suited to tight and accurate drawing subjects – architectural plans, diagrams, mechanical detail and such – also, writing. They're less well suited, perhaps, to loose or lyrical sketching.

Filaments come in a range of thicknesses, from 0.9 millimetres (mm) down to 0.3mm. Most stores will stock mainly 0.5 to 0.7mm. I favour the 0.7mm (given my heavy hand, a 0.5 lead is forever snapping on me!).

A **chinagraph pencil**, by way of complete contrast, is made of hardened, coloured wax. It can be used to mark other surfaces such as glass or rock – but, for our purposes, paper will do just fine (less heavy to carry about).

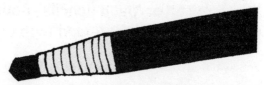

The end result is greasy in appearance, and satisfyingly black (although grease pencils do come in other colours: Walt Disney reputedly favoured red).

Top TIP: Working a chinagraph pencil over a dried patch of type correction fluid gives great textures. True grit!

Coloured pencils

You can buy coloured pencils in a huge range of hues and tones – individually, or in sets from small to large. Amazing effects, subtle or dazzling, may be achieved with these – none possible to show you here in black and white, aside from these pointers ...

As with most art materials, you get what you pay for. Cheap products give cheap -looking results. Still, as materials go, a good set of colours remains relatively affordable in pencil form.

Blend and/or layer them gradually to build up form and lend the illusion of depth.

To achieve strong contrasts, shade softly, and then sharpen for a harder line.

Look out for **water-soluble** pencils – taking a wet brush to marks made with these expands the possibilities for your drawings, almost akin to painting in watercolours.

Top TIP: Blue Pencils

Use an ordinary light blue pencil for more tentative construction drawing, or an 'under drawing' layer. Why? It is effectively invisible to photocopiers and scanners (when set to 'text' or 'black and white' mode). Electronic light is blue – it does not see itself.

Many artists and designers habitually draw in blue instead of using an ordinary graphite pencil, and this is the reason. It means that you can avoid having to erase your mistakes as you go, most especially if you then go on to ink or otherwise commit to your original pencilled drawing. It's as if the blue lines exist on their own separate layer, not reproducible by photocopy or scan, to leave you with a clean final image.

This is only true, of course, so long as you don't press down super hard when making your marks – otherwise some trace is sure to come out.

How to Draw

(Obviously, blue lines show on any full-colour scan.)

Other, related types of drawing tool include **Crayons**, **Charcoal**, **Chalks** and **Pastels**.

Wax crayons are often (wrongly) dismissed as kids' stuff, for kindergarten or simpletons. (Well, colouring-in was also once thought the strict preserve of the nursery, and if we can accept and make that fashionable ...) There's no stigma to using crayons.

Chalks, charcoal and pastels are all what might be termed *plastic* (as in malleable) media – you can get in there with your bare hands and fudge and smudge things around, getting your fingers artistically dirty.

This is just as much fun as it sounds. And the results can be hugely pleasing.

Likewise, it would be wrong to disregard anything about the practice, experience, or the results as necessarily childish. These are not mere finger-painted daubs, in any sense other than their most literal description.

Don't believe me?
Suck on these **pastels** for a start ...

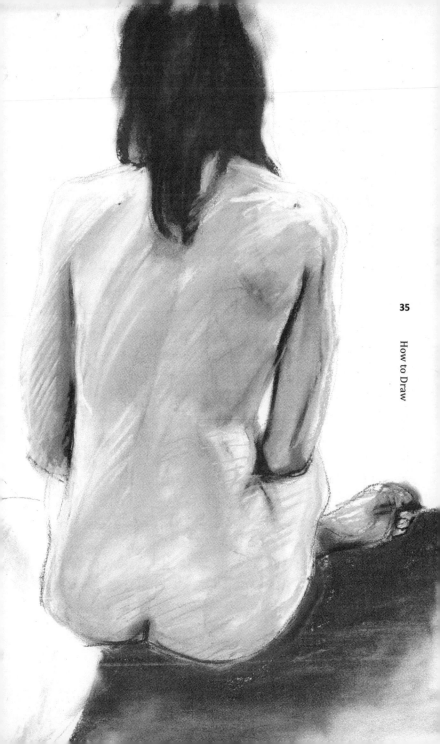

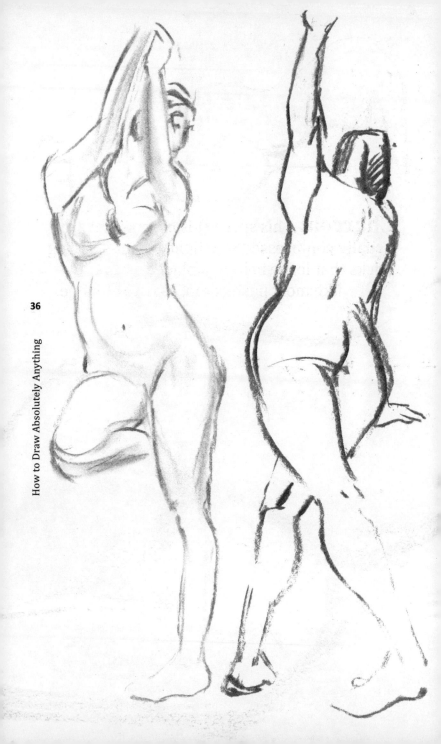

How to Draw Absolutely Anything

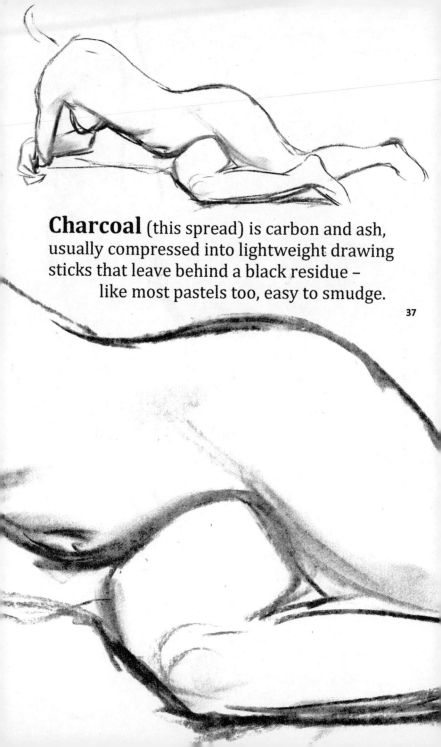

Charcoal (this spread) is carbon and ash, usually compressed into lightweight drawing sticks that leave behind a black residue – like most pastels too, easy to smudge.

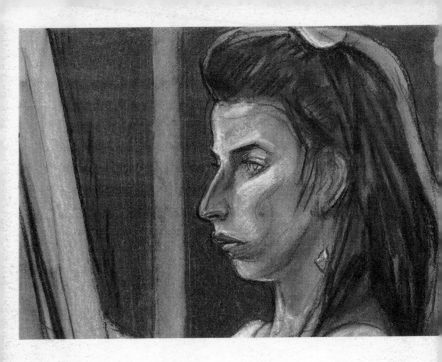

Charcoal may also come in the form of a
charcoal pencil.

A soft pastel meanwhile is a crayon made of
pigment, together with a dry binder to hold
it together. When made of oiled chalk, it is
an oil pastel. If made with wax, it's a wax
pastel, or what we normally call a crayon!

This drawing has been done with **chalk**
(**above**, and **right**). Chalks are sticks of
compressed powder without any such
binder, neither dry, oil nor wax.

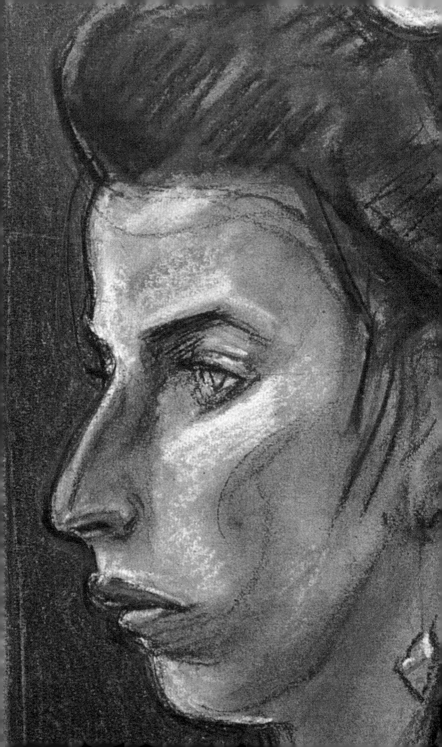

We'll return to explore drawing technique and activities to help achieve these sorts of results in more depth shortly, but for now ...

Fudging and smudging = *Sfumato*
(you say sfoo-may-toe, I say s'fu-ma-to)

Google has it: 'the technique of allowing tones and colours to shade gradually into one another, producing softened outlines or hazy forms.' This is how Leonardo Da Vinci crafted his famous *Mona Lisa*. Areas around the eyes and the corners of her mouth are indistinct, or at least less distinct. Precise expression (and thus the emotion conveyed) is open to interpretation – contributing greatly to the painted portrait's perennial mystique, and consequent popularity.

FIXING
Once you have completed any drawing in a plastic medium such as chalk, charcoal or pastel (wax crayon is more permanent), you will need to 'fix' the image to preserve it. This is done with an aerosol spray fixative.

Top TIP: When it comes to buying fixative, a can of 'firm hold' hairspray does the job just as well as any dedicated (but pricier) art shop brand. There's no guarantee, however, that it will smell any better.

DRAWING IN **INK**

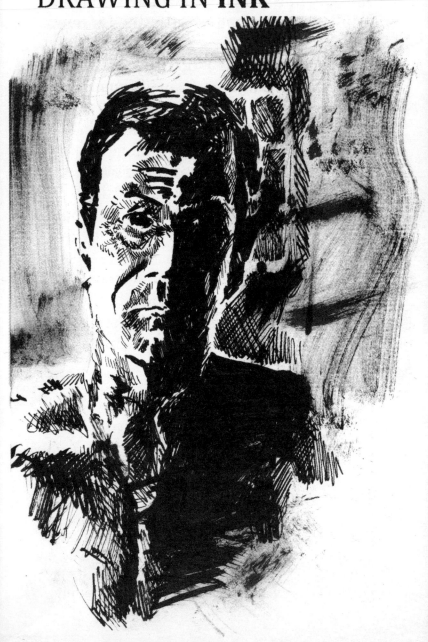

Pencil is *subtle* – depending on the weight put behind it, a pencil can produce an infinite range of tones.

Other related drawing tools such as pastels, chalks and charcoal perform likewise.

ULTIMATE CONTRAST

Ink, meanwhile, is very *definitive.*

You can inscribe a thin line, or daub a thick one,

but ——————————————

the mark is very much *there*, or *not there.*

In terms of *tone* value, if not hue (inks come in a veritable rainbow of colours), one might say that instead of an infinity of greys, the choice is stark – black, or white?

INK takes no prisoners. INK shoots on sight.

This entails a wholly different approach to drawing ...
producing entirely divergent effects.

An Aside ... An Eraser of Love

One of my many workshop students once told me that she preferred to draw directly in ink, precisely because this stopped her from second-guessing herself.

Drawing with a pencil, she would spend her whole time rubbing out – erasing her work. That was feeding her insecurity, her doubts. She felt so uncertain of her drawing abilities that she had to find some way to commit.

Drawing in ink is a true test of commitment. There's no hiding, and there's no fudging. You have to think on your feet – or else, trusting to fate, fly by the seat of your pants. Once the mark is made, it is *made*, and it's up to you to make it work, or to live with it (adding more marks often isn't a solution!).

I don't necessarily mean to make this sound heroic. It isn't for everyone. There's no shame in *not* doing it. But I would say that DRAWING DIRECTLY IN INK is good practice.

Forgetting ink for the moment, you can also let this level of commitment carry over into your pencil drawing – all of your drawing.

I was perfectly serious when I suggested earlier that you throw away (or at least put aside) your pencil erasers.

Instead, try this simple rule:
DON'T ERASE.
If you feel it's going wrong, don't erase your drawing – go with it, try to work through it.

Here's another: NEVER THROW AWAY.
Don't screw up your drawings, or chuck them in the bin. If you must abandon them, unfinished, OK. Just don't destroy them, no matter how much you might dislike what you have done. Keep them. Keep them all.

Then, when you feel ready, look at what you drew – last week/six months/two years ago. Compare these to where you are now.
If you don't keep drawings, you will have no track record of your progress.

Types of INK PEN

TECHNICAL PENS
(aka. rapidograph, isograph)
Pros: steady flow, opaque ink, 'professional'
Cons: expensive, high maintenance

FELT TIPS
Pros: wide range of point sizes, cheap
Cons: run out quickly, variable ink quality

MARKERS
Pros: choice of broad chisel tip (pictured)
or fine bullet nib (like a Sharpie)
Cons: stink. Have you smelt a Sharpie?

BALLPOINT PENS, or BIROS
Pros: versatile, cheap, convenient, *chewable*
Cons: comparatively weak ink, can blob

The first thing that you will want to do, as you should with almost any art materials, is noodle around with them a bit – take any scrap of paper handy and first get familiar with the feel of the pen in your hand.

EXPERIMENT to see what sort of marks each pen makes ...

... note how they differ, assess what suits you best.

Top TIP: Make a note beside each set of marks, recording which brand of pen as well as which point size or nib you're using, as a reminder.

With **MARKER PENS**, it is worth trying out the whole range that is available. The pens come in various sizes. Here is one such set, with felt tip widths from 0.1mm to 0.5mm.

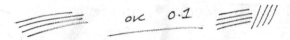

As I have explained, my hand naturally moves fast. Note how ink flow risks petering out at this smaller size, forcing me to draw my test lines more slowly.

FINE LINE felt tip marker pens such as these can run out of ink very quickly, so once you have found the type that works best for you, it's worth buying them in bulk, and always working with a fresh pen each time. As the ink supply fades, so does your line ...

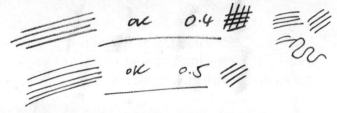

Conversely, the more you use a felt tip with a heavy hand, the more it can flatten out, thickening the line. An 0.2 can end up marking like an 0.4. Keep *testing*!

Here is another set. This time, designation of the different sizes of felt tip or nib is alphabetical rather than numeric. We have:

Artist pens: **XS** (eXtra Small), **S** (Small), **F** (Fine), **M** (Medium), and **B** (for Brush)

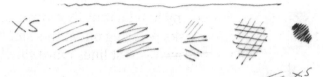

As before, note how very light the thinnest lines are. I've had to scan carefully so that they reproduce at all.

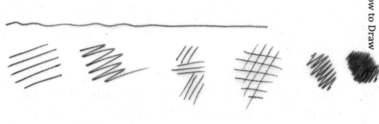

And again, as the ink begins to run out, or the nib wears out, so the lines begin to drop out, until marks made with an **S** more resemble an **XS**.

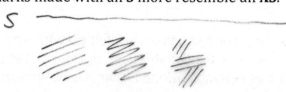

F (Fine)

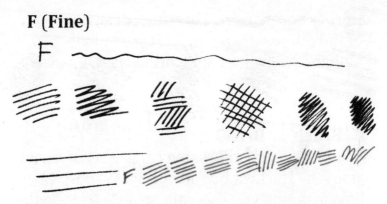

With faster hand movements, you can *taper* the line (the pen stroke ending thinner than at the start). The heavier you press, the bolder your line.

M (Medium)

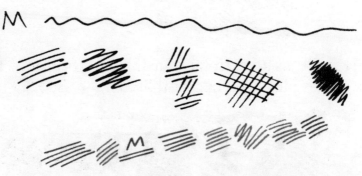

The same effect, a bolder line, arises when your nib begins to go blunt. This thickening of the line means that marks made with a blunt **F** more resemble an **M**. Or with a blunt **M** ... uhhh, an **XM**?

Knowing this, you can work it and make USE of it.

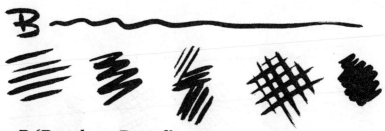

B (Brush, or Broad)
The brush tip in this same range (artist pens) gives the thickest but also the most variable line, meaning you can gain lyrical effects with it – but it is also the hardest to control.

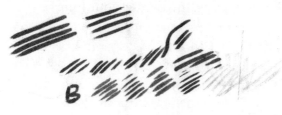

Finally, as an extra option, **C (Calligraphic)** comes packaged in sets that include the **XS**.

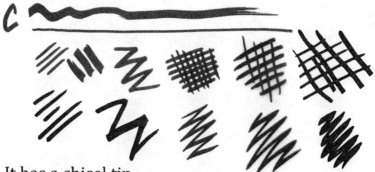

It has a chisel tip,
making broad marks when turned one way,
and thin the other. Tricky, but interesting.

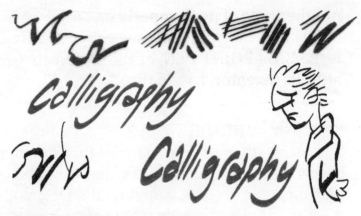

Calligraphy is the art of writing or lettering. Traditional to many cultures, particularly Arabic (the basis for our own alphabet) and Islamic as well as Oriental, it may smack of wedding invites or monks, yet these 'pictures in words' are also the root form of most modern urban *graffiti*. The thick-to-thin flow of calligraphic pen style comes closest in feel to that of a dip pen, or quill – in writing *or* drawing.

Pen in hand, turn it one way then the other to vary line width.

Another type of pen properly invented with lettering in mind, but often used for drawing, is the **BALLPOINT PEN**, or BIRO (named after its inventor, László Bíró).

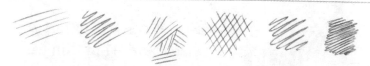

(Spot the pesky ink blob at the start of the first and third lines – a characteristic of this particular pen.)

Cheap and cheerful, biros are very popular to draw with. A versatile inbetweener with an easy flow but a hard tip, the biro is subtle, like the pencil. With a light touch, your line can be delicate and feathery. Applying more pressure yields immediately darker results. Swift, chunky strokes soon build up infinite tonal variations. Very responsive, the humble biro is convenient and quick to master.

Many ideas for artistic masterpieces started out as just another idle telephone-pad doodle in biro. (The latest mobile phones, with their touch-sensitive screens, merely carry on this grand tradition).

INK and PAINT BRUSHES

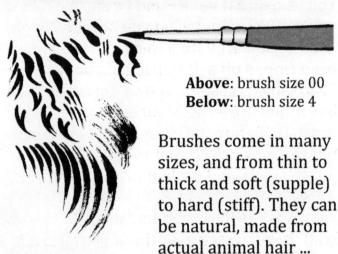

Above: brush size 00
Below: brush size 4

Brushes come in many sizes, and from thin to thick and soft (supple) to hard (stiff). They can be natural, made from actual animal hair ...

... commonly sable (a *mustelid*, or stoat-like creature), to hog's hair or bristles.

Or, they may equally be synthetic, made of artificial fibres such as polyester and/or nylon.

Some people swear by one type; others, the other. Different strokes for different folks!

BRUSH QUALITY

You've heard it before and I'll say it again –
you very much get what you *pay* for. No one
makes good art with a cheap old brush that's
been ripped off a dead badger's bum.

True sable is costly. Even so, *caveat emptor*,
buyer beware – check out each and every
brush tip before purchase. LIP IT – when
moistened, does it taper to a single, fine
point? Or has it got a bad case of split ends?

Same with INK – cheap Indian ink is vicious
stuff. It will wreck your finest brushes. It's
also *viscous* – it can thicken over time. Thin
it if necessary with water: ideally, distilled.

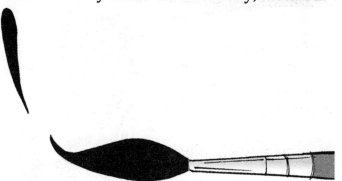

Variable ink flow

For the best ink effects, load your brush with
ink (if dipping), or press down and go slower
(if cartridge-fed). A WET brush allows a lot
more lyrical variations from thick to thin.

Dry brush technique

At other times you might actively want a patchier finish. Staunch first, making a few wet strokes on a blotter sheet or scrap paper over to one side of your artwork, then apply. With cartridge brushes, hang on to the ones that are running out of ink, or in need of an imminent refill, using them deliberately dry.

Top TIP: Q-Tips

You know those cotton swabs on a stick that you're meant to use medicinally, or with make-up, but not meant to stick in your ears because they will impact the wax? Yes, those. If you are ever filling in large areas with lots of ink, use a cotton bud. They soak up ink real nice and spread it out further. Plus, it saves wrecking your expensive brushes when doing this.

Top TIP: Two-in-One

That artist pen with a B for Brush tip? (see page 51) Once the fibre tip has become worn down, blunted or bent, pluck it out carefully and turn it around – there's a fresh, sharp tip at the other end of it! The manufacturers are quiet about this for some reason. I was stunned when someone first showed me.

BRUSHPENS

A Japanese innovation, the mighty brushpen (a fibre brush, in the form of a pen) is a modern marvel – and a saving grace for those heavy-handed or impatient, like myself, who find the whole business of dip pens, brushes and bottled ink too fiddly and finicky.

The best brand is highly expensive, but each refillable brush can last a long time. When the ink supply begins to run low, as shown here, simply pop in a fresh cartridge.

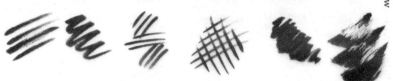

Brushpens have proven such a big hit among artists and designers (I heartily recommend them myself), that many brands of felt tip also now do their own 'brush' tip – a cheaper alternative. Hugely variable, some types are good and flow freely, although the ink is often a less solid black than in cartridge versions.

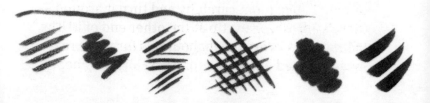

HAND TO EYE COORDINATION

Activity: We said, 'Try everything.' And we meant it.

Try EVERYTHING.

Try out EVERY SINGLE DRAWING TOOL that you can get your hands on.

Do this to find out your own hand to eye coordination and how it works.
Is the drawing movement of your hand *light* or *heavy*? Is it *fast*, or is it *slow*? Or is it a combination, more than one of these things?

Establish what your instinctive tendency is, and then go ahead and get familiar with it. Draw, draw, then draw some more – it doesn't really matter too much what.

SCRIBBLE, DOODLE, just make some marks. Experiment fully, learn, then lean towards and ultimately go with what comes the most naturally (at least to begin with). Adopt and use the tools that best suit the way that your hand moves, and best suit you.

Nothing beats personal experimentation to arrive at your singular findings. Still, for your ultimate convenience, here are some potentially time-saving recommendations, based on my own broad experience ...

SLOW HAND

Hard pencil (H)

Technical pen

How to Draw Absolutely Anything

Soft(er) pencil (B)

Felt tip

LIGHT HAND

Hard pencil (H)

Technical pen

Brushes

HEAVY HAND

Soft pencil (B)
Chinagraph pencil

Felt tip

Brushpens

Of course, some drawing tools work almost universally, for any hand speed and pressure:

Ballpoint pen, or Biro

HB pencil
Midway between hard (H) and soft (B)

Technical (Push) pencil

And
Crayons, Pastels, Chalks and Charcoal

Let's take a closer look at some more images – no prizes for guessing where I was when I drew this **biro** sketch. Witness its versatility, from delicate froth to a shaded dark stout.

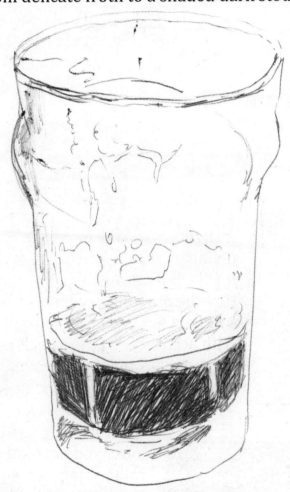

How to Draw Absolutely Anything

But was the glass half-full, or was it half-empty?
(I had to take another long gulp of beer in order to help me decide ... and hey presto, problem solved!)

In terms of TECHNIQUE here, holding the pen lightly and loosely in the hand allows for it to trip freely about the page, to trace the detail of beer suds drying on the inside of the glass.

A slightly *firmer* grip is used to delineate the outline of the glass itself – but not so much pressure that the drawing becomes stale, by being too firm or preoccupied with accuracy. This is a beer, not a cut-crystal chandelier. Evoking feeling and atmosphere counts.

Then, *shading*: again loose and haphazard rather than tight or rigidly disciplined, as befits the subject matter. Keep it free!

MIXED MEDIA

Let's mix it up. Here's a drawing of spaghetti sauce. It's mostly done in coloured pencils.

The pencils are water soluble, so once the main shading is done I go over it lightly with a small, wet brush. This adds a little extra gloss. Final touches of white gouache paint add shine to the sauce. Mmm, yummy!

What? You didn't know you could mix your drawing tools up any which way you like?

By way of further example, here's a simple sketch of a sleeping partner. Umm, I mean, a partner...asleep.

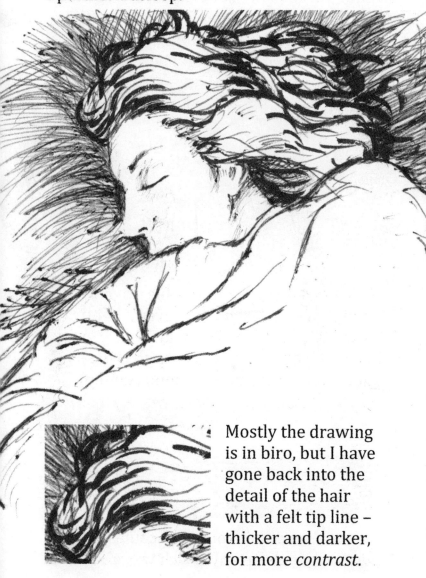

Mostly the drawing is in biro, but I have gone back into the detail of the hair with a felt tip line – thicker and darker, for more *contrast*.

BRASSED OFF

In this study of a brass instrument, I've used different types of pencil. Tones are built up, starting with harder pencils and a lighter touch, then increasing pressure, and softer pencils. Finally, chinagraph borders in black.

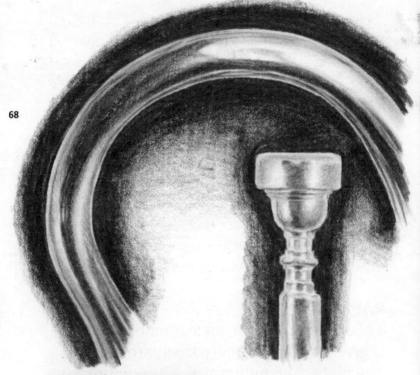

Looking closely, you can see I pencilled so *hard* that the paper started to fray and crack.
LESSON LEARNED: use a better quality of paper.

Types of DRAWING PAPER

The paper stock you choose may prove important, according to what drawing tools you ultimately settle on.

Matters for consideration include the paper's *weight*, its *opacity*, and the *finish* (whether it is rough or smooth).

Discover what papers work best for each tool. As a general rule – *smooth* suits HARD, and SOFT relishes paper with a bit of bite.

PAPER WEIGHT
The standard metric measurement for this is given in gsm (grams per square metre). The higher the numeral, the heavier it is.

OPACITY
Can you see through the paper? If so, by how much? This has to do with the thickness of the paper as much as the type.

FINISH
The ways in which paper is manufactured affect the qualities of the surface you will be drawing on.

Paper may be said to have degrees of *grain*, or 'tooth'. Grain, in this instance, as with wood (from which most paper is made), indicates the amount of fibre present, and its direction. More grain equals a rougher surface – sometimes not so obvious to the naked eye, but palpable to the touch. Papers may be smoother on one side than the other.

Always check.

Bargain Shopper
Almost every sort of paper is available to buy separately as individual large sheets. Trim these down if you need them to be smaller.

The price when buying whole pads of the same paper may at first seem a deterrent, but savings are made to the cost per sheet when you buy in bulk.

It's no different from toilet paper if you think about it. But that's not so hot to draw on.

Cartridge paper is a good all-rounder, readily available and reasonably priced.

Photocopier paper is only 80gsm. Aim for something a bit thicker, more opaque and robust – around 130gsm or so. You can of course go higher, as you like. This improved density also gives the paper a brighter white sheen – contrast that shows off your drawing.

Cartridge is good for pencil because it has a slight tooth to it, but also for drawing in ink, because that tooth is slight enough so as not to catch the nib or tip and cause it to skip.

Thick ✓ **Dense** ✓ **Tooth** ✓

Pencil ✓ **Ink** ✓ **Pretty much everything** ✓

More grain or tooth becomes essential when working with pastels, chalks and charcoal – these need resistance in the paper's surface for them to catch on and be truly effective. There's great tactile pleasure to be had in drawing with the crayon family over coarse ground. **Sugar paper** is probably the most economic option of many. Start there.

Tooth ✓ **Cheap** ✓

Watercolour paper

(Bockingford, Canford et al). Thick is best. Be aiming at around 300gsm. Lesser weights may absorb too much water and distort. If the paper appears to buckle at first, don't be alarmed. Once the wet has been absorbed the paper tends to regain its shape. This is also good for working with water soluble pencils.

Thick ✓ **Absorbent** ✓ **Opaque** ✓
Paint ✓ **Ink** ✓ **Water** ✓

Tracing paper

is thin enough to see through. As the name suggests, it's meant for copying by tracing. Good as it is for that, the smooth surface also takes both pencil and ink well, especially markers. Get it too wet, however, and it will wrinkle. And unlike watercolour paper, it won't recover.

Thin ✓ **Transparent** ✓ **Smooth** ✓
Pencil ✓ **Ink** ✓ **Markers** ✓

Layout paper

is a luxury graphic design favourite. Whilst extra strong and a bright white, it's also thin enough to trace through. Great for corrections and planning stuff out.

Thin ✓ **Strong** ✓ **Semi-transparent** ✓
Pencil ✓ **Ink** ✓ **Markers** ✓

Marker pads are, as the name suggests, made for just that. Another specialist – and suitably expensive – designer option. If you draw with markers, nothing works better!

Thick ✓ **Strong** ✓ **Semi-transparent** ✓
Markers ✓ **Markers** ✓✓ **Markers** ✓✓✓

A thick, smooth, heavyweight **card** stock is best for felt tip and other ink drawings – including pencil drawings that you then intend to ink. Start out from at least 120gsm. Ordinary papers get creased and fray easily. Card lasts longer, especially if you are going to be handling it a lot while drawing. It also makes for a good, professional presentation.

Thick ✓ **Smooth** ✓ **Strong** ✓
Pencil ✓ **Ink** ✓ **Markers** ✓
✓

PAPER **SIZE**

It's more convenient to use small pads for ease of transport and instant on-the-spot sketching. But in terms of paper size, when drawing at your leisure, bigger is definitely better.

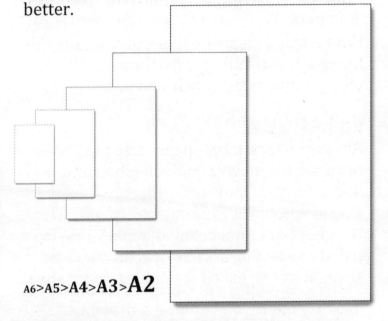

A6>A5>A4>A3>A2

A6 size is equivalent to a postcard; A5, a standard flyer, like you'd get put through the door; A4, a sheet of letterhead or photocopy paper; A3 is a poster; A2, a large poster.

Going larger still there are A1 and even A0 sizes (at 150% enlargement each time). But these are pretty huge and hard to handle. You should do fine with sheets of A3 or A2.

Don't be parsimonious (that is to say, stingy) when it comes to using paper. Always have plenty to hand. Be ready and willing to use it up and wear it out, sheet after sheet.
I always exhort my students to 'Eat paper!' After all, it *does* grow on trees! BUT, recycle!

Have a spare page or pages ready to one side for roughs, scribbles, tests, thinking aloud with your pen and pencil, and so on.

GO **LARGE**

Always go for a larger paper size than you need. Do this to give yourself elbow room – literal room to move, as well as space either side of where you concentrate your drawing. Use this extra dimension as a mark-making palette or testing area. As it is on the same sheet, it's of an exactly matching paper stock.

Besides, isolating your drawing central to a larger sheet makes it look more impressive. Suitable for framing!

2. HOW TO DRAW ABSOLUTELY

(Technique)

MARK-MAKING
GET READY, MAKE YOUR MARKS, GO!

<u>LINES</u>

Soft line

Hard line

Slow line

Fast line

Thick line

Thin line

Short lines

Brush line

Wobbly line

Straight lines

Activity: Drawing is not much more than letting a line take you for a walk. Let's *go* ...

Start here. •

Finish here. •

On as many separate sheets of paper as you like, at any size, plot for yourself more start and end points. Above, below, beside – vary how far apart they might be. And of course, you don't have to go straight. Your line may wander anywhere in between on its long or short journey from start to finish.

See how many DIFFERENT sorts of line you can think of to draw, and make them. Or, switch off your conscious brain and simply let yourself go. Draw. Relax and let the pen or pencil in your hand find its way.

BECOMING ABSOLUTE

One way of drawing is with what I call the 'fuzzy', 'feathered' or even the 'hairy' line ...

... that is to say, a series of short, tentative lines or marks that are run together.

This is done instead or in place of a single, unbroken line.

You may find that you naturally draw like this ...

... when really, the way that you'd *like* to draw is this ...

The hairy line can often be a sign of nerves or uncertainty – a failure to commit to making a single, strong or certain mark.

But why be *negative* about it?

Drawing in short strokes doesn't have to be seen in this way. Nor does it necessarily have to stay that way if it's not what you want.

You can choose to draw the hairy or feathered line *lightly* ...

... in order to plot the route of a more certain single line through it.

In other words, the feathering can be used as a way and a means to FIND YOUR LINE.

The stronger line drawing *emerges* more clearly from the mass of less determinate feathered or 'hairy' lines.

OR – especially if the 'hairy line' is how you find yourself drawing more naturally – you can choose to make a *virtue* out of it.

Virtues such as a greater sense of *movement*. Don't fight it. Instead, embrace it.

Allow the way that YOU draw to develop into YOUR STYLE.
(You might say, Follow Your Own Lead.)

Activity: Here are more hairy line drawings. Get in some practice. Find your single line version by drawing over the top of them.

So, in summation, you might say that there are the lines that the various drawing tools give you (the lines that you get), versus the lines that you actually want. The distance between these is where the *frustration* of the artist is most often found.

The tendency is to blame yourself, to feel that you are simply *not very good*. I would strongly recommend that you get over it. Reject this assumption and this feeling.

It would be more correct to allow that you're only just beginning to find out for yourself what's possible, what is not yet possible, and also what might yet *be* possible. You are exploring your *potential* by taking these very first steps towards realising your own style.

The final form your unique drawing style might take is unknowable. It shouldn't even exist. If you approach drawing in the right way, you will *never stop* developing. The more you draw, so your skills will accrue. The quest is endless, and the frustration too.

No matter what you feel or think of your drawings at this early stage, DON'T GIVE UP.

DRAWING TECHNIQUES

Over the course of this book so far, we have been building up a virtual *test card* of the different sorts of marks that you can make.

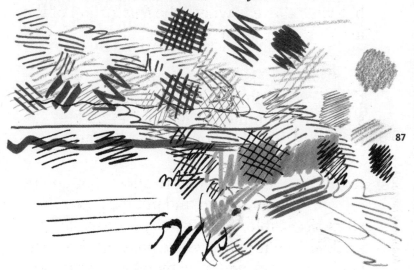

SHORT STROKES

In addition to the various sorts of line, we now begin the short strokes, *aka* feathering.

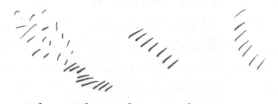

Start with quick, pecking stabs.
Gather these into sets of short lines – not so much lines, more jerky, gestural dashes.

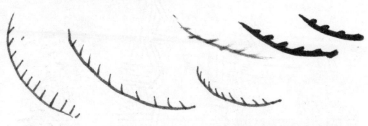

Use a BROADER TIP pen or pencil and try leaning in to the dash, flicking off and away as soon as you hit the paper. Aim to leave a slightly *tapered* mark, reinforcing direction.

How might this be applied in an actual drawing? Well – draw a line, curved or straight. Then depart from it using these same *dashes* or *flicks*.

That's one simple way to suggest an edge to an object, implying as it does both TEXTURE and DIMENSION. More about these ... later.

What might our mystery object be? You decide. For this one I've added marks to a ring shape. Pull back – and have a donut! With sprinkles, if you like.

Working with a BRUSH or BRUSHPEN, the same taper effect is more obvious – but this takes a sharp tip, a light touch and practice, otherwise the brush flicks appear blunted.

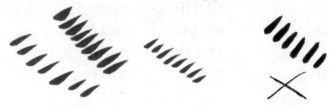

Gathering these sorts of dashes together, changing direction each time, produces a *patchwork* or kind of basket-weave effect.

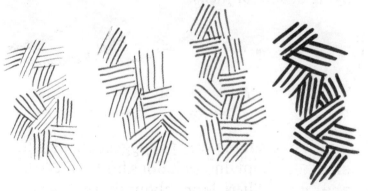

Evolve *feathers* into *fur* – gather your dashes again, but this time staying in one direction, or else only gradually shifting.

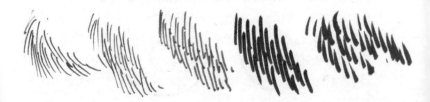

Now *this* time, go for making the same sort of short hand gestures, but instead of flicks, maintain contact as you move back and forth. It almost amounts to controlled scribbling.

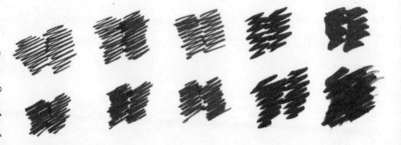

The *heavier* the marks plus the *closer* they are together, the more we begin to approach SHADING. (This is another drawing subject we'll be giving more consideration to later.)

Activity:
Try *all* of these movements with EVERY tool.

In terms of the kind of marks that your own hand will make, everyone has their personal comfort zone – some people feel more at home with shorter gestures, others longer. Don't just copy what's here. EXPERIMENT!

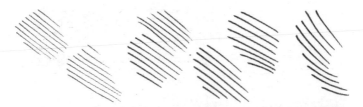

You should also try out **LONGER STROKES**.

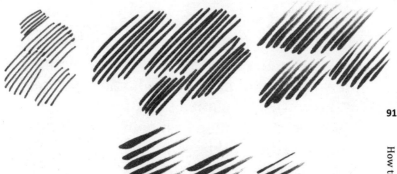

I am very impatient – my drawing strengths lie in another direction. A sure and steady hand (and temperament) can make these sorts of marks more neat and regular.

GOING DOTTY
Something else now. Start out with pecking motions similar to before, DOTS this time. Regular or chaotic, just as they come ...

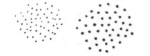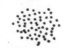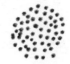

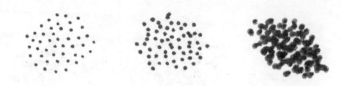

You can play with the *density* of the dots as well as the size of them.

This kind of mark-making has a name. It is called *stippling*. (Stipple effects most likely arose from the art of etching or engraving, an early form of print reproduction. Marvel at the works of Gustave Doré, for example. Then reckon on them first being etched into a metal plate, working with wax and acid to produce the final printed image, all the while in mirror-reverse, and be trebly astounded!)

Where were we? Oh yeah ...
You can start to mix up the marks you make. Explore combining hand motions in between dots and dashes (= a *pebbledash*, as below).

Don't forget that you can also swap between tools while working over the same patch.

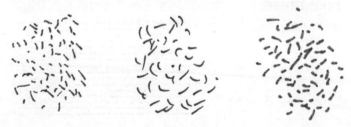

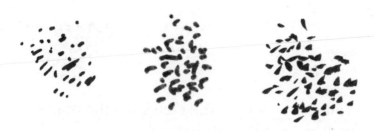

The larger the tool, the more variant stipple effects you can get with even slight changes of hand movement.

So, hopefully you begin to see that drawing is not just a matter of lines or outlines. Images may be developed from raw mark-making in any number of ways.

HATCHING

Let's go back to lines again for a moment. I want to explore another drawing technique that likely comes from engraving, or at least came into widespread use because of it. *Hatching* is a way of creating tonal or shade effects using parallel lines – mostly, if not always, closely or regularly spaced.

Like these:

CROSS-HATCHING is when perpendicular sets (opposing angles) of line are combined, to create the perception of progressively darker tones or shades.

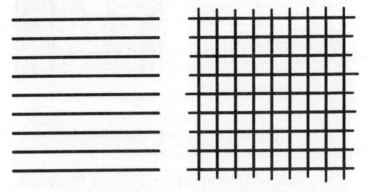

If your first set of lines is HORIZONTAL, the next one is VERTICAL. If you then want to go darker, 45-degree ANGLES come into play.

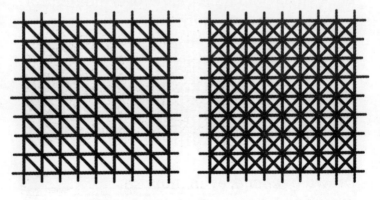

To see works by one of the best modern proponents of this technique, go to: www.nickhardcastle.co.uk – also permanently installed along both platforms of Wapping underground rail station, London, UK.

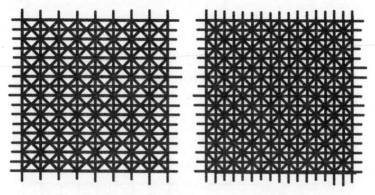

Back to further horizontal and then vertical lines, displaced to subdivide the remaining space. Obviously this gets quite technical ...

The grids so far shown on this spread were created digitally, via computer-aided design. Drawn by hand, even with the use of a ruler (**below**), the results tend to be much more haphazard – excusably part of their charm?

Drawn *freehand*, even more so. When lines (or dots) differing in relative size, spacing or angle are superimposed, a visual jangle results – a pattern called a '*moiré*'.

MOIRÉ?!

How to Draw Absolutely (Technique)

DOODLING

As soon as you like, you can progress from this most basic form of mark-making – scribbling and so on. Take on the roster of tools, line widths, strokes, stippling, dashes, dots, etc. that we have been exploring for the last twenty pages or so. See it as your MENU to draw from. (**This page**: pencils, ink; **Opposite**: biro)

Let your mind as well as your hand roam carefree, creating spontaneous doodles. There should be no more pressure, no greater concentration, than when absent-mindedly scrawling on any old paper scraps while doing or thinking about something else. (Once called telephone pad doodles – presumably, in our mobile age, something of a lost art. RECLAIM IT!)

Hey, want to see something *really* scary?

AAAAAAAAAGGGGHHH!!

The Terrible Tyranny of the *Tabula Rasa*

Don't be afraid of a blank page – it won't stay blank if you just START DRAWING.

At this stage, the drawing itself doesn't have to *look* like anything. It doesn't have to *be* anything. It could be any thing or no thing.

The blank page is nothing to be scared of.

Whether you have bought yourself a swanky brand new sketchpad of exclusive Ethiopian vellum-finish cartridge, or picked up any old notebook at hand (either will do fine), don't let yourself be daunted by each fresh papery expanse with nothing yet showing on it.

Make paper of whatever sort your *friend* – use it like it's going out of fashion (because it is!), treat it like it grows on trees (because it does! OK, so I made that joke already).
'Eat paper' means stock up on it – *fill* it up, *use* it up, and then *move on* to using more.

Inevitably you will feel that you're getting it *wrong*, but feel the pain and DO IT ANYWAY.

If you find that you really have a *problem* with staring down a blank sheet of paper (artistic equivalent of what's called 'writer's block'), you can TRICK the mind by working on **lined paper**, or **squared graph paper**.

Part **pre-printed** pages can be found in any one
of the many doodle/scribble 'creativity' books now
on the market, meant for you to add to in your own
way – no substitute for the real deal, but useful for
limbering up and even fun … DO IT here and now.

Activity:

Go on,
FILL my
face in!

Another way to bypass facing a dumbfounding blank page while also limbering up, is to adumbrate or *embellish* existing images. I sometimes doodle by filling in extra details, usually over photographs in newspapers and magazines – especially faces, adverts, or filling blank spaces in the page design. Think of it as *graffiti*, your chance to answer back!

Likewise there are options to *trace* over images you like (learn by working out what makes them tick); and *collage*, as **above** (I've industrial-taped over a glamour model to make a new multimedia artwork).

You are ready to move on from improvising (doodling at random), towards SKETCHING.

Q. WHAT IS DRAWING?
A. = Impulse. You might even say *instinct.*

Drawing is the handy ability to get your thoughts, ideas and feelings down quickly and easily in a form that anyone, anywhere, might appreciate and understand.

Q. WHY DO WE DRAW?
A. = Basic Communication.
Hands up if you have ever played the board game Pictionary.

(Um, no, not *naked* Pictionary. It's summer and everyone is in short sleeves.)

Mankind's first ever drawing was probably in actual fact a *stencil* (a hand print, or rather the impression of a hand – *negative space* left remaining around the hand in blown raw pigment).

What does it TELL us? Possibly, 'I was here'.

As an art student, I'd make drawings of the sort of haircut I imagined for myself, to show my barber exactly what I wanted (**below**).

(As it is said, a picture is worth a thousand words – although, like most hairdressers I'm sure, mine ignored any/all directions and just did as he liked. Not a problem I face anymore, now that I'm bald!)

A (Very) Potted History of Drawing

Starting out from the further evolution of *cave drawings* (paintings), we have the cave dweller's shopping list or *wish list* – buffalo wings for lunch!

Lower image: Art by Clara Jetsmark, www.clarajetsmark.com

Our written language, if not spoken language, first developed from pictures – Mayan *glyphs*, Egyptian *hieroglyphs*, Chinese Han/Japanese *kanji* – all visual alphabets. In ancient civilisation, Arabic, Greek and Roman scholars would scribe on clay tablets. Look at us now, with our computer tablets and electronic styluses. How little has truly changed.

DIGITAL DRAWING

TO INFINITY AND BEFORE

A brief detour from adventures in fibrespace (*aka* paper). We journey now to the notional environs of *cyberspace*, looking forward, to present and possible futures ... on computer.

We are living in an era of the conversion and compression of seemingly everything into pixels and data – including our artworks. Only a few prescient people saw this coming.

'In the (1980s, David Hockney) was experimenting with computers ... as well as Polaroids, fax machines and photocopiers. More recently, he has painted using iPhones and iPads. Whenever anyone has questioned this way of working, he points out, "Anyone who likes drawing will like to explore new media."'
– Rohan Silva, *Evening Standard*

Pioneering fine artist Hockney relates how, back when he started down this road, the technology was still relatively primitive. There could be a ten-second delay between his drawing a line and its appearance onscreen. This was also my experience, around this time. Colouring any digital image with a *'fill'* command, you first had to ensure every line was unbroken, each shape enclosed, or else face a half-hour wait while the computer doggedly filled in the *entire screen* and *beyond* (the total digital space).

Things have come a long way since then, and continue to evolve at light-speed. **Computer Aided Design** can these days replicate pretty much anything and everything.

HORRIBLE DISEASES (delightful); digital colours and FX

Whether the art technique or finish you're aiming to mimic is charcoals, chalks, or their more controlled technical pen and pencil brethren, be assured: digital drawing allows for the simulacrum of *any* of these media – and, what's more, in an endlessly random yet at the same time entirely controllable environment. Sounds good, yes?

Most drawing programs include versions of all these media and many more in their extensive menus. And, when it comes to a choice of *background*, you can have it on (the illusion of) sandstone, or rough canvas, or burlap, or … you get the idea. Or DO you?

Much drawn material today is purely digital. No pens, pencils, erasers, paints ... no paper.

I still choose to draw 'old school', by hand. BUT I then scan my drawn images into the computer in order to correct, colour, alter or otherwise finish them off – making them transmittable, for a blog/social media feed or whatever (as if I ever have time to run one!) – and also (as with absolutely everything you see in this book) print-ready.

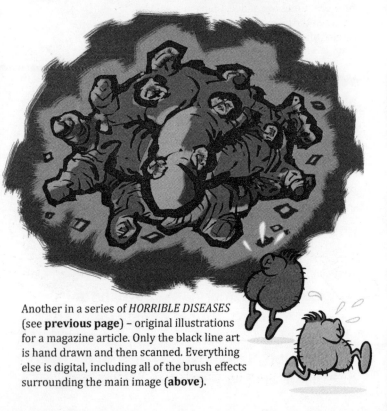

Another in a series of *HORRIBLE DISEASES* (see **previous page**) – original illustrations for a magazine article. Only the black line art is hand drawn and then scanned. Everything else is digital, including all of the brush effects surrounding the main image (**above**).

An in-depth guide to digital techniques would need a whole book. I can only give these basic pointers ...

1. The tight line drawing (inked in technical pen over a pencil sketch) is SCANNED into the computer (it's an image about oral hygiene, riffing on Picasso's *Bathers*, no less).

2. Working on a separate LAYER, colours or (here) tones are added, filling in areas between the lines. These may be flat, or else blends – anything's possible.

3. Some of the lines themselves are then SELECTED, and also coloured or toned (no longer solid black – check out the dental floss).

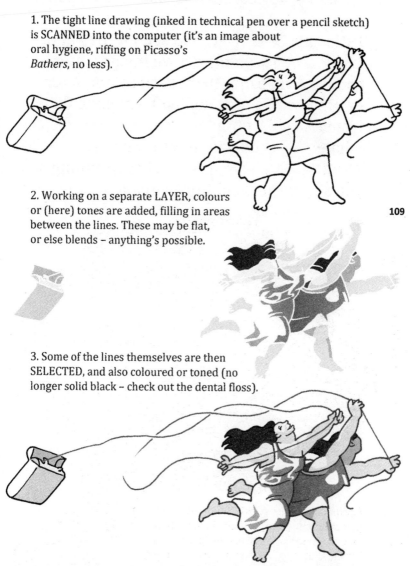

4. FLATTEN the image (compress layers). And there you have it.

Working with computers, it's important that you don't let the program take the lead.

There are equivalents, such as *CorelDRAW*, etc. But the daddy, most widely used in my experience, is *Photoshop*: designed to doctor photographs (which is by no means a new phenomenon – it's been done with whiteout and graphite since at least the 1920s).

When it comes to drawing effects, *Photoshop* offers well-nigh infinite possibilities and variations.

Decide on the look you want to achieve before you begin, then pursue it via experimentation with all of the various tools in the array and their drop-down menus (make note, for future reference and to build your repertoire, of how exactly you arrive at any happy accidents that should occur along the way).

You will find your own favourites. Mine include the *select* tool, *brush* tools and *chalk* settings, amongst many others. Photoshop is vast – each artist finds his or her own routes into and through it. (I don't know anyone who's ever read the flipping manual!)

MACHINE INTELLIGENCE

Try not to get carried away with the instant 'new toy' aspects of it all – the endless shiny shines and blends and applied lens filters. Good design doesn't tend to come from an explosion in a paint factory.

Like shoddy CGI, art very obviously done on a computer is a turn-off for many viewers. It can look very same-y – after all, it comes from the computer as much as any person.

Can you take sole credit for the results when a machine's done most of the work? (*Poser.*)

No, I don't say that as an insult. I bring it up as a prime example, Public Enemy No. 1 for 'bad' technology. *Poser* = animation software. When people have used it in their drawings you can always spot it a mile off. Avoid!

Chill ...

As we've established, computer programs are able to replicate almost any visual effect. What's been missing so far is a palpable match to the physical processes *behind* the mark-making. Yet the latest, really smart technology achieves precisely this.

Touch-sensitive Electronic DRAWING TABLETS
Wacom, *Symtec* (and other Terminator-sounding tech) present us with a convincing analogue to the brute joys of scribbling and finger daubs. At last we make our glorious return to blissful caveman simplicity ...

These drawings were created on an iPad by Paul Harrison-Davies, paulhd.blogspot.co.uk or instagram.com/paulmhd. The app is called *Finngr* (you can also upgrade to *Finngr Pro* if you like the smell of it. I'm sorry, the sound of it). Works on an iPhone too, apparently, and, as Paul says, 'It's dead cheap'.

Opposite: Steps to a shining example.

Believe it or don't, this most excellent *life drawing* was actually done on an iPad Pro, using *Procreate*. Says the artist, Kev Hopgood, www.kevhopgood.com: 'There's no big secret as to how I drew it. It's pretty much how I'd draw with traditional materials – only with cleaner hands!' We'll take a good, close look at some more life drawings shortly.

There's also **Ascii text art** (examples **above** and **below**)
– a sort of return to hieroglyphs, the original smiley
webdingbat emoticons. Google 'text-art', *aka*
'shift_JIS' art. You can see gatherums of these online
at fsymbols.com/text-art, and textart4u.blogspot.co.uk.

Mona Lisa, from
All This Is That,
by jackbrummet.blogspot.com

Train Man (*Densha Otoko*) was a multi-platform (ho ho) phenomenon – manga (Japanese comic), novel, TV series, movie – ostensibly based on a true story of a young *otaku* (nerd) who intervenes when a drunk harasses one of several women on a train.

After a protracted *lonely hearts* search played out in public over the internet, the pair find each other again and become a couple. The novel, as with the 'original email' exchanges, features Ascii art as a part of the messaging intrinsic to its narrative.

(I know all of this because I designed a cover for the translated UK edition.)

1. The first pencil sketch has a more cartoony face to reference manga, but I change it.

2. Next, I ink the image in black line, varying the widths by using different pens (small, fine, medium).

3. Note how the detail in the hair is included as a black line – I plan to turn it white, but only once the image has been digitised.

4. Scanned at high resolution as a bitmap file, then greyscaled and converted to CMYK, colouring or toning begins. I do this in the two-colour style of cel animation.

5. Working in layers, and carefully selecting areas, I add in effects like these *radial shines* for the train headlights (in white tones). Very hard to do, unless digitally.

6. Another subtle radial blend to the face helps to attract the eye, highlighting character emotion. Note too the freckles and sweat – no longer in solid black line.

The mouse is included in homage to Terence Cuneo, famous for his painted scenes of trains and railways. Search any one to find his trademark hidden rodent.

eek
eek

An infinite future wonderland of digital abstraction beckons. But beware – *Here Be Tygers* ...

HOW TO ... **WHAT'S NEXT**?

Given the ambitious title of this book, an advance reader reasonably asks:

'Will *HOW TO DRAW ABSOLUTELY ANYTHING* tell me how to draw plants, trees and cars? I assume so, as I believe they fall into the "anything" category. If so, I'll have to get a copy.' – Mr Robert Wells, Kent.

Good point. Our focus here is much more on the *HOW TO DRAW* part, Robert. We could include whole chapters on drawing plants, trees, cars ... *ABSOLUTELY ANYTHING* – but this would only get us so far (i.e. not very).

As the old adage says: Either I could give you a fish and feed you for a day, OR I could try and show you how to fish for yourself, and you'd be fed for a lifetime. Or fed up, maybe.

Using step-by-step examples I could tell you how to draw one peculiar fish, OR I can show you HOW TO DRAW so that hopefully you will not only be satisfied with your drawings, but also *want* to draw more, and then go on to explore for yourself how to draw as many fishes as you wish – or absolutely anything else that you'd care to. Now, who's *hungry*?

Opposite: *Come with me if you want to live ... Not digital! Not one bit!* A manipulated photocopy collage by Carl Flint, www.carlflint.com

LET'S GET **SKETCHING**

The **HOW HOW** and the **WHAT WHAT**

We all have specialist subjects that we want to draw the most, but also things we tend to struggle with. For instance, I'm perennially asked about HANDS (I'll return to this later).

Some folks wrestle with bodily proportion (their ideals for them), ears, or even placing feet. Others crave correct perspective. (We are, for some unearthly reason, entirely obsessed with accurate representations of reality – when reality is already all around, for everyone to see. Talk about redundant!)

Personally, I hate drawing buildings and cars. But it's important for me to know enough about drawing – know enough about how *I* draw – that I can draw myself a building or a car when I absolutely have to. (And in my job I *have* had to, many times over.)

CHOOSE YOUR WEAPONS
Since WHAT you draw will to some extent govern *how* you decide to draw it, then that should also dictate (or at least suggest) what TOOLS you might choose to work with.

EXOTIC FISH AND CHIPS (*hold the chips remix*)
Monoprints plus newsprint photocopy collage

The **technical pen** (rapidograph) renders a line that is both thin and absolutely regular. (It stays thin – no deviation in width at all, regardless of hand pressure. Lean in heavier and all that will happen is a snapped nib.) That, to me, suggests *machine* qualities.

Take a good look at the image on the page **opposite**. I've concentrated hard to keep my lines straight, yet (after lots of practice) elect to draw them freehand (without a ruler). This is to keep the image feeling *alive*, not a dry technical exercise. Maybe I cheated it halfway by tracing along the edge of an overlaid piece of stiff paper – an improvised ruler – I forget.

Note how I have let some lines overrun. There's no real reason for that. It's self-consciously 'arty'. But, I'll go with it. Endorse my artistic licence.

I wanted the dark interior of the washer to feel immediately different, warmer – as if the machine's cycle has just finished – so for the sake of contrast, I switched materials to a few differing grades of soft B pencil shading.

The perspective looks pretty accurate, if I do say so myself, but it is estimated, freehand (again, more alive). It is an artistic interpretation, but, other than that, I'm recording what I'm looking at exactly as I see it.

And dammit – it's a *tumble dryer*, isn't it. (er, whoops)

Model No 37278

WATCHING MACHINE (Model No. 37278)
Technical pen (rapidograph) and soft B pencils

Rest assured, this one's an end result of a whole *day* of sketching – don't necessarily expect to catch something like this straight off (although that can happen too!). Normally, you'll have to draw a right load of rubbish first to get properly warmed up.

If you peer in real close, you can still make out a few of my **preparatory sketch** lines done in what looks like chinagraph pencil (especially around the moob area).

This is construction drawing, to map out in advance on my paper or pad the thing that I'm planning to draw, in full, before I commit to any finished marks. I get down the major details, the rough proportions, to ensure that all I want to include *fits* on my page.

This can be quite loosely done, and is a *guide* only – where I've freely departed from that first sketch is where that same under-drawing remains visible.

After that, I'm free to let rip, going ape with my **ink brushes**. Some thin (top of head, right shoulder), others thick and loaded with ink. Very deliberately I use the effect of a drying brush, as the ink runs out, to suggest the gorilla's fur.

Note how I expend more time and control on the face – this is what I want to pull *focus* on. This guy was pretty intense! (Guy the Gorilla ... no? Anybody?)

BE THE GORILLA
Chinagraph pencil plus brush/dry brush

What do the, um, washer/dryer and gorilla have in common? Both are sketched from life. They are observational drawings, each drawn *in situ*: one in our kitchen, the other at the zoo. (I'll let you guess which, where.)

EXOTIC FISH AND CHIPS (a few spreads back) and *Cider Punk Wa-Hey XXXX* (**opposite**), though inspired by and commenting on real life, are patently not real. They started out as a blank canvas – drawn from the imagination.

The newsprint background to *Exotic Fish* is nothing more than an ordinary newspaper, screwed up and flattened onto the glass of a standard photocopier. Take a closer look at those particular, peculiar fish.

The line sort of looks like pencil, except somehow ... fuzzier? Phuzzy phish? How did I arrive at thish? (Hmmm, that cider stuff is catching – and strong!)

It (and the image opposite) is a **monoprint.** What's a *monoprint*? I'm glad you ask ...

MONOPRINT.

A Monomaniac is someone obsessed with a single thing (say, uh, drawing). Monotonous? Is that same person, droning on and on about it. It's also a bit like this book: Monochrome! (That means one colour print.) *Mono*, mate: there can be only *one*.

A monoprint is a *single print* taken from an image created with oil- or water-based paint or printing ink, working over a hard surface such as stone, glass or metal. No two prints are alike, although further impressions may be taken (a *positive* or a *negative* print). For more detail go to www.monoprints.com.

Opposite: the actual reverse side of my *Cider Punk* (positive) print. See the hard line drawn there. That transferred the ink, leaving the image overleaf (back one page). I drew it spontaneously on a stained, inky piece of scrap while in the middle of something else – but this is the one I chose to keep, a smiley wiped into the ink traces there (a negative impression!).

Monoprint is variously described as being painterly, free, versatile, direct and impromptu – to that add filthy, dirty and delirious: a punk, drunk as a skunk on scrumpy cider.

BUDGET MONOPRINTING

How I got the fish effect on p.121: heavily shading one side of a sheet of paper with the softest pencil I could find (probably an 8B), I then turned it over. Clean side face up, I laid the shaded side down on top of a fresh sheet. Using a hard pencil (4H or above: any hard stylus will do), I inscribed my fish design. Wherever I pressed down transferred the soft pencil to the sheet below (in that, it's a bit like tracing). Draw firmly, but on target – anywhere you press, shade will transfer. Presto! This is your homemade monoprint.

EMOTIONAL INTELLIGENCE

So far we've talked about how *how* you draw can be affected by *what* you draw – what the subject matter of your drawing is.

There's also the *emotional* spectrum – your own body's response will affect the drawing, and also yourself, as both artist *and* viewer. Let's say you are a parent drawing a picture of your own child, or vice versa. Your whole approach, and the results, may differ from your drawing of, say, pollution, or a corrupt politician. *May*, did I say? Should!

TRY IT OUT. On the page opposite, draw something that you feel a strong liking or love for – a small image will do for now. It might be foodstuff, a person, an object, or even a fairly abstract notion, like 'happiness'. Then, below that, draw something else that you conversely feel a strong dislike or distaste for.

The sort of marks that you make – also, the ways in which you make them – will most likely to some degree reflect the *sympathy* or else the *antagonism* that you feel.

(Carry on experimenting with this exercise if you wish, on separate, larger sheets.)

Activity: Draw something here that you feel a strong *liking* or *love* for.

Draw something here that you feel a strong *dislike* or *distaste* for.

This isn't simply a matter of how you feel about what you are drawing. It also comes down to, 'How do you *feel*?'

One great thing about almost any creative act, drawing not least, is that you are able to *express* yourself. When you get in tune with your feelings – good or bad – and can then express them, you're moving stuff through your system and will feel much better for it. The choice of subject matter for drawing can play its part in this, too.

Let's say you are feeling *dumb* and *stupid* (for whatever reason). Then try drawing something dumb and stupid – maybe a dog.

That might be me being mean about dogs (I confess I don't much like them – long story). Still, a dog *is* fun to draw and to me at least it suggests these things. You may, you can – and probably should – come up with your own ideal expression of 'dumb and stupid'.

If, however, you feel your drawing is going wrong even as you do it, and this frustrates you, draw *this* feeling out too.

Allow yourself to *express* your frustration in the moment, with the marks you make.

Very usefully, this also shows you a way to effectively *describe* such feelings in your drawing, which then becomes another part of your ever-swelling *repertoire* – the skillset that you will always be able to return to as both creative person and human being.

Bonus – afterwards, you may find that you no longer feel quite so frustrated or angry. You *drew* it out of your system! JOY!!

An Aside ... Anger is An Energy

At a recent two-hour practical workshop, after drawing only a few mask-like heads, one of my students came to a dead halt. She told me that she suffered from OCD, which is an Obsessive Compulsive Disorder. She felt so down about her drawing that she had become furious with herself – effectively paralysed and unable to continue.

OCD aside, I deal with confidence issues not unlike this all the time – it's quite common.

My advice to her is the same as it is to you – try to make *use* of how you feel about your drawings, or your drawing abilities, by understanding this as part if not parcel of your self-expression. Troubled by demons of doubt? Then acknowledge them, head-on. *Draw them out.*

The worst thing would be to give up, to not even try. Any anger you feel (*anything* that seems negative and draining), USE IT. Depict the feeling itself in the marks that you make. Rather than be defeated by it, work with it – and work it through and out of your system.

Don't let anything stop you; least of all, YOU!

3. HOW TO DRAW ABSOLUTELY ANYTHING

THE MAIN EVENT
DRAWING FROM LIFE

THE ART OF THE SELFIE

The self as subject matter has served artists throughout the ages, from Rembrandt to Picasso and beyond. No budget required. Always readily available, any time of day or night – wherever you may go, there you are.

We live nowadays in a selfie culture, largely due to social media. Carefully composed or on the fly, using a panoply of mobile devices, folks are constantly snapping *self-portraits* – images of themselves, their outfits, their food or their activities. Incessant self-assessment to this extreme – such a need for constant reassurance – is, it has been noted, not good for us.

So let's *make* it good. We can, instead, turn this narcissistic self-regard into something much more beneficial to our mental health – through the art of drawing!

Opposite: *Self-Portrait* in thick marker pens. You can see by traces at the far left of the image that I sketched my drawing in pencil first before committing to the sudden death match of ink. Posing against a strong spotlight increases contrast and shadows. Marker bleeds into the paper keep things alive. NB: I can't draw my drawing hand!

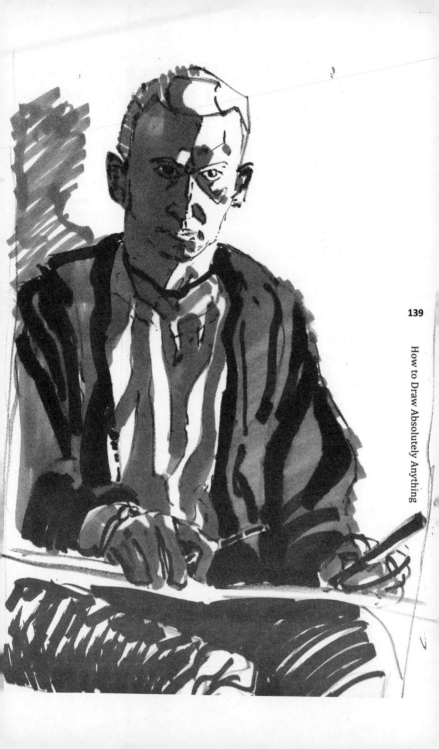

The aim of the self-portrait – as with any drawing from life – is to *study*, *observe* and *record*.

Left: Another marker image – this time with pens that are dried out (I'm experimenting). It looks like I have *boss eyes* because I'm looking up, around and down to record my facial features. Obvs!

Opposite: Moody charcoal selfie.

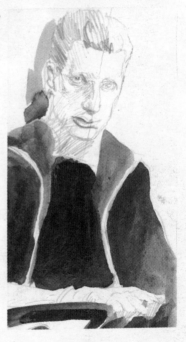

Above: Some lines are oddly elongated. I think I'm looking for directional emphases.

Right: Pencil and ink selfie exploring contrast & hatching.

It's not about making yourself look good. It's not even – necessarily – about capturing an accurate likeness. Ultimately, it is an *exercise in drawing*. No more and no less.

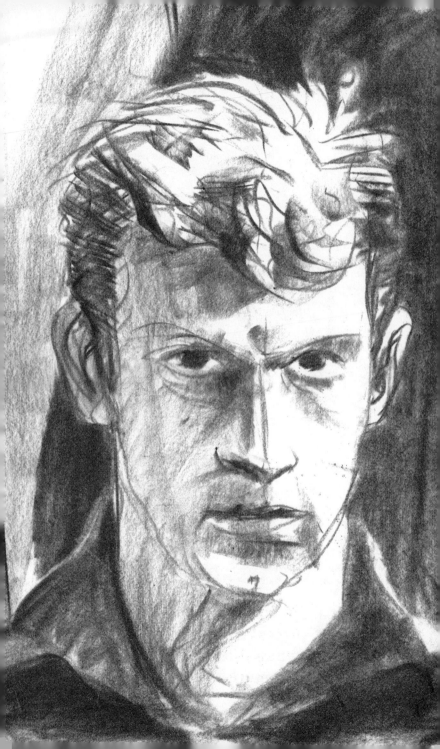

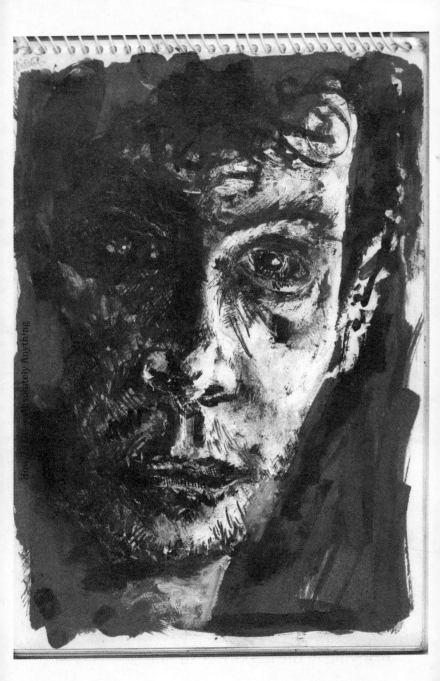

How To Draw Absolutely Anything

Since you are never lost for a subject, why not take this opportunity to *study* it in all sorts of conditions, and from any aspect or perspective, size shape, form, etc., just as much as you like.

MIXED MEDIA
Try different materials, see how they work, how they suit you, what effects you can get from each of them, and in any combination.

Here's an example (**opposite**), a portrait in, let's see now – Indian ink, Tippex (white-out correction fluid), felt tip, a bit of biro, a few smudges of charcoal, and back in again with more ink.
It's a multi-medium, minor miracle extravaganza!

Try out different lighting conditions ...

Move the light source, from overhead, in front, behind, to either side ...

... bright or dim, and anywhere in-between, explore the full range of possible *contrasts*.

One or more spotlights, dimmers or angle-poise lamps can be useful in this regard.

Drawing in the *dark*? Not so much.

Don't get too caught up in whether or not the end results *look* very much like you or not, nor indeed whether or not you *like* them much, if at all. What's more important is the act of drawing by itself – what you can *learn* from it, the sheer level of *practice*.

Imagine for a moment you could turn out a perfectly accurate drawing every time – how dull and boring that would be, to do, and to look at afterwards: how very pointless.

When and where we learn is from our mistakes.

Selflessly and at great personal cost I've got this next picture WRONG, just to prove my point – and yet somehow *undo* it at the same time. No, no, I'm *reinforcing* it – my point, that is – by trying to fix it afterwards. Yes.

Opposite: A pencil portrait, using a broad range of densities from hard (H) to soft (B) pencils.

I started with a very light outline, invisible almost, to give the (false) impression that there's no outline or holding line. I wanted to convey it all in *tones*.

Becoming so all-consumed by the cross hatching, I drew my face way too long, re-cut, and *patched* it.

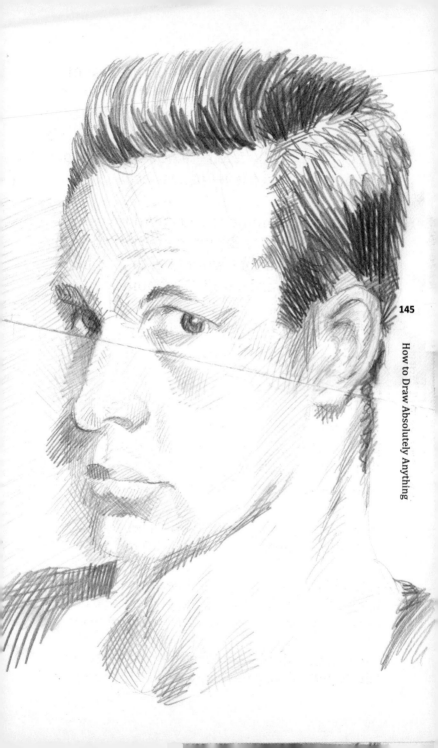

How to Draw Absolutely Anything

FOOLS RUSH IN?

If you should feel you've gone wrong with the basic proportions (as I've done, just now, letting myself get distracted by details while the face itself comes out too long), this can usually be avoided by taking a more *measured* approach. But you should also know that I don't necessarily always advise it.

You *could* get into the habit of always doing a light, quick sketch first – 'roughing it in' – an outline of all you mean to draw, making sure it fits your paper, estimating proportions by eye (according to where you are viewing from, or wish to see it from). This is *before* concentration on detail, style or rendering.

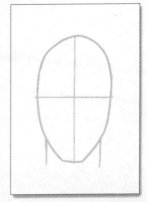

Plan for the paper you work on. If in doubt, always use a *larger* sheet. Don't cramp your style. This beats running out of room partway through your drawing.

If drawing a portrait, for instance, or even a made-up head, block a rough *outline* first. Plot the main points to make sure it all fits, and fits together how you *want* it.

This same basic principle applies *whatever* it is you are planning to draw and however you plan to draw it.

At the same time, there's more *science* and *discipline* to the underlying construction of most persons or objects. I'm going to skim over it here because it's been covered in every drawing book ever since the dawn of time and I'd be AMAZED if you haven't run into it a thousand times already. And more.

CONSTRUCTING THE HEAD AND FACE

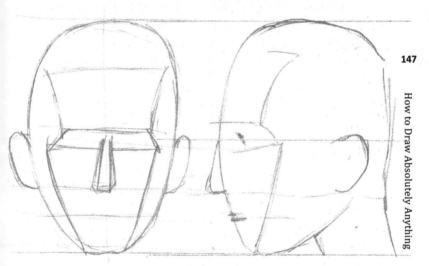

The simplest way to tackle the human head or face is to reduce it first to a very basic *oval* or egg shape.

Situate the eyes *halfway* down, and hang the ears off this same halfway line. Divide the remaining face area in half and half again to locate nose and mouth.

This same construction may then be turned through 90-degrees to plot the head or face in profile.

Using this same basic method, you can turn the constructed head to pretty much any angle that you want, while keeping it recognisably alike.

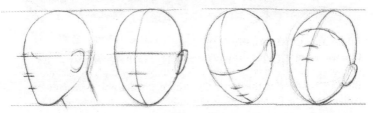

Here are a few more heads with greater detail filled in.

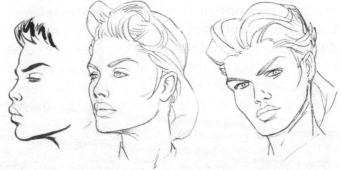

How the *hair* is arranged can have a major impact – the way it frames the face, but also on how we perceive that face, the person or character that it belongs to.

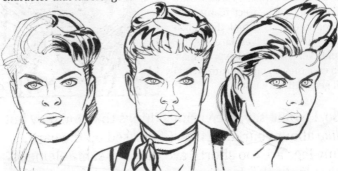

Note how I try for a *looser line* and some *fluid brushstrokes* to depict the qualities of hair (some people are great at this, but I don't really have sufficient facility or patience for it. I should try harder!).

A Valuable GENERAL PRINCIPLE
One way to make your drawing seem more than 2D lines on paper is to suggest *mass* and *volume*. Do this by darkening and/or thickening the lines that define the underside – here, the lips and especially the chin or jawline. Faked solidity 'grounds' the subject, whatever it is.

I resist going into too much further depth on these aspects – the construction beneath any drawing – because as a professional artist I sincerely begin to doubt their validity, let alone usefulness. I've come to think that it's ultimately a mistake to reduce anything to any sort of *formula*, whether in a quest to make it seem 'correct', or for any other reason.

Not everyone has a face that can be reduced to a simple *shape*, be it oval or whatever. Not many faces even stay *consistent*. One of the problems of a Hollywood culture, even more so trash TV, is the total dominance of 'perfect' features. Everyone starts to look the same – the stars themselves daren't get old and even avoid facial expressions in case they should start to wrinkle. It gets dull, very fast.

So, I would say, the various things that you may not *like* about your drawings ('I messed up the ears', 'my legs are too short') are the very same elements that *make* the drawings more original, fun, worth doing, and also worth looking at. We don't (at all) look the same. We shouldn't all *draw* the same.

A brief, closer look at how *techniques* and *materials* can have a bearing ...

Opposite: I've used a little loose *crosshatching* on the armchair, to depict shadow. Of more interest, in the aged face, see how *switchback strokes* with the nib pen convey sags and wrinkles (apologies, Gran). I've isolated a couple of these in the enlargements (**below right**). Marks like these, we explored by *scribbling*.

In the more youthful felt tip portrait (**below**), the crosshatching remains loose, but fairly *one-directional*. It suggests shadows, yet smooth skin.

cond)

back of
head, in
biro

In these sketchbook studies, various different *tools* impact on technique.

Left: Little more than a doodle with a *felt tip pen* that is on its last legs. Again, the quick, gestural pen marks have their roots in scribbling. A Farage-go?

Below left: You can bring in Fine Art techniques at any time you like – here, in a cheeky nod to CUBISM, a hairstyle has its angles and planes squared off. Try others: Pointillism, Fauvism, etc.

Below: Or try celebrity portraits – here's one of Prince (r.i.p.), smartly, for someone who wore lots of make-up, rendered in a *soft, kohl-like pencil*.

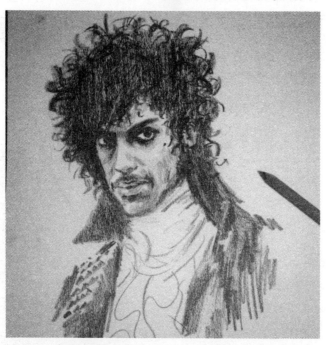

AND HE IS FUNKY by Paul Harrison-Davies, www.paulhd.blogspot.co.uk

Portrait of the Artist as An Angry Young Man
Too much staring at myself in the mirror has
got me into a right old strop. Tune into your
own MOODS or FEELINGS. Consciously or
not, they are anyway *transmitted* in the sort
of marks that you make, so embrace that and
allow them to influence your drawing. A *sad*
drawing will come out very different(ly) to a
happy, *reflective* or *nervous* one.

Express the drawing suitable to its subject.
Calm? Amused? Furious? Second that
emotion with acting and drama! (*Be* the Gorilla...)

Opposite: Portrait in thick, black oil pencil. Note the *speed* and
energy with which the marks are made. The angles distort. Somehow
this only *adds* to the ferocity and power of the expression.

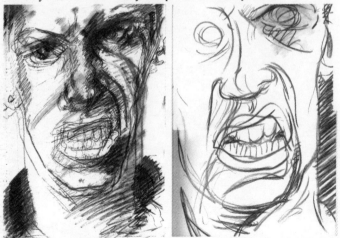

Above, **left**: Photocopying my *Angry Portrait*, I hit upon the idea of
running it through the machine twice to double-expose the image.
Literally shaking with emotion! **Above**, **right**: Finally, I abandon all
study, and just *free-associate* the feeling in a loose charcoal riff.

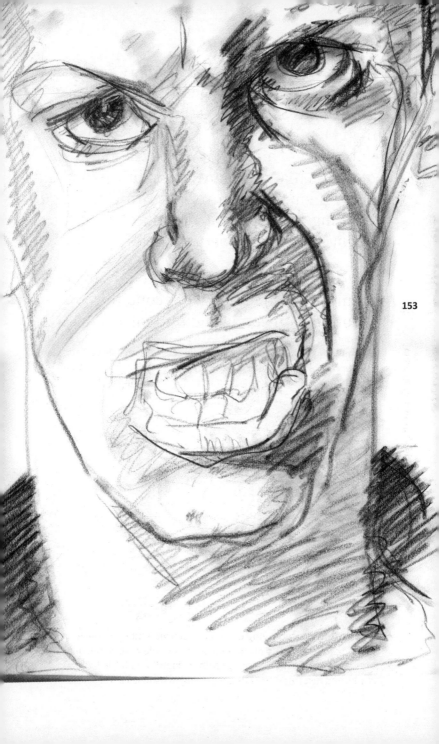

153

MONKEY VERSUS ROBOT

At an opposite extreme, we turn to *digital* portraits. My instinct, perhaps predictably by now, is to try to subvert strict programming in order to make the results more chaotic, or 'humanise' them.

Above: I perform a digital trace of my source image (a photograph), plotting out the main details. Once these have been digitised, they can be *manipulated* in the computer in any number of ways. Want to look thinner? Compress the image to immediately lose weight! And so on.

From the same source photo, this time I plot separate elements with my stylus and cursor in a sketchier style. The computer matches my every move, producing its own versions as a kit of parts (**opposite**). Merged onto a single sheet, I have a computer-drawn sketch portrait!

Below: Here's base data digitised from another traced photo-portrait. First off, this only results in quite a bland line drawing. HOWEVER, this is just our point of departure ...

Opposite: *THE BOY WHOSE HEAD EXPLODED* ... If I then ask the computer to extend the marks it makes, in random directions from every plotted point entered: deviations that begin 0.1cm in length, advancing by degrees to 4cm, why, I can almost teach it to *scribble*! One might never guess the final results ever came from a computer.

These *digital sketch* effects were achieved back in the 1980s using relatively primitive programs and machines. Computers have advanced by multiple generations since then. What sort of drawings might YOU train or trick your hardware and software into making?

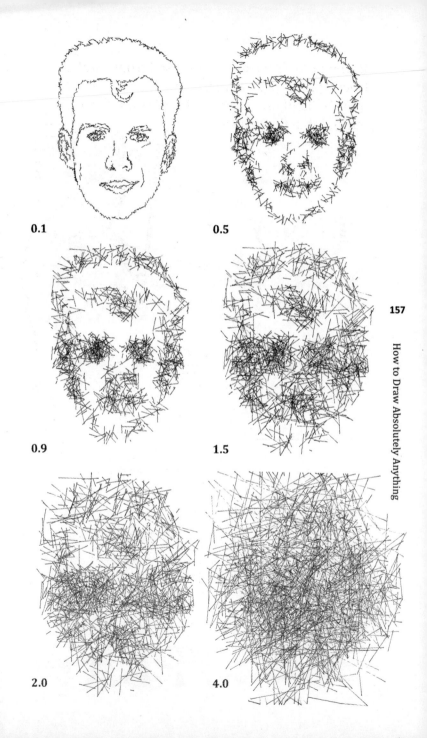

0.1

0.5

0.9

1.5

2.0

4.0

Secrets to successful drawing include –

PLAY TO YOUR **STRENGTHS**

BUT ALWAYS BE READY TO **CHALLENGE** YOUR **WEAKNESSES**.

It should be fairly obvious, but I'll cop to it now, I have a *figurative bias*. I love drawing people, studying the human figure. (Similar textbooks you might see will concentrate on landscapes or 'still life', artful arrangements of objects.) As a human myself, drawing the human body feels natural and right to me. (By the same token, lizards most likely want to look at other types of lizard – especially naked ones.) So, we'll take on *Life Drawing* as our primer for further in-depth study ...

BUT ALSO ...

... PLAY!

FIGURE DRAWING
(LIFE DRAWING)

Charcoal is an especially good
medium for this. It is quick, versatile
and malleable – easy both to correct,
and to redraw things with.

Observation and Study –
STRUCTURE

How to Draw Absolutely Anything

HAND
REACHES
MID
THIGH

In terms of bodily *proportion*, the average adult is traditionally held to be six heads high (some have it that we are evolving towards eight). It can be useful to reduce the body and limbs to interconnected *parts*, rather like an insect – thorax, abdomen, midriff, etc.

The **HUMAN BODY**, as indeed most things, may be broken down into essential shapes: a *sphere* or *square* for the head; the limbs, upper and lower, as *cylinders*. Ball joints – more spheres – form the junctions in-between.

The ARM, just the same as the LEG, may be best understood as a series of such shapes run together in sequence.

If drawing an entire limb seems daunting, *first* break it up into its constituent parts.

How to Draw Absolutely Anything

Continue working out the rest – HEAD and BODY, plus how they connect – in this same way. Once you have it down pat, you can begin to *move* the various parts of the body through (an illusion of) space.

To angle the forms in 'space', let the building shapes overlap in sequence. This is known as *foreshortening*.

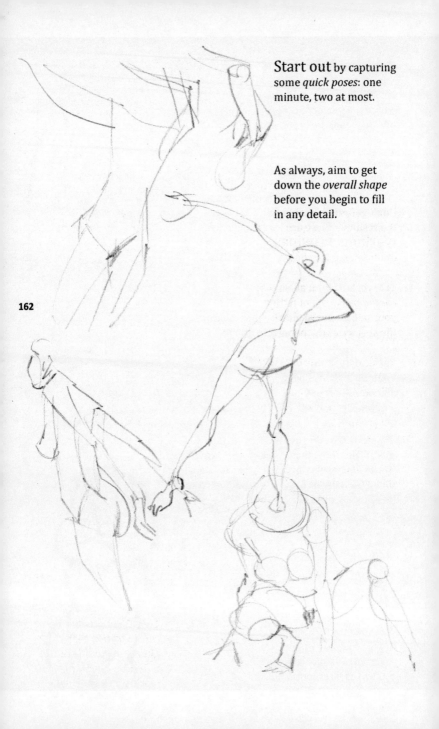

Start out by capturing some *quick poses*: one minute, two at most.

As always, aim to get down the *overall shape* before you begin to fill in any detail.

162

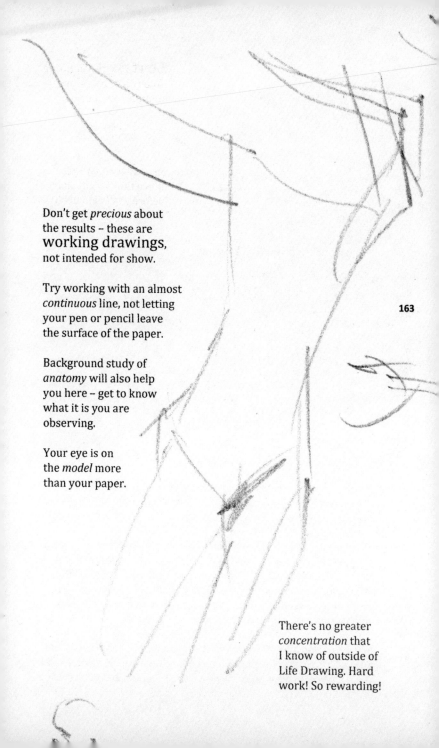

Don't get *precious* about the results – these are **working drawings**, not intended for show.

Try working with an almost *continuous* line, not letting your pen or pencil leave the surface of the paper.

Background study of *anatomy* will also help you here – get to know what it is you are observing.

Your eye is on the *model* more than your paper.

There's no greater *concentration* that I know of outside of Life Drawing. Hard work! So rewarding!

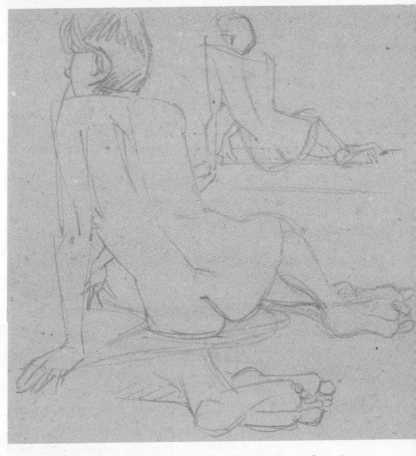

Progress steadily on to *longer poses*, still only three to five minutes in duration. Move freely around the model to find the best angle to draw from each time. Choose what *aspect* you will concentrate on.

There are *many* possibilities. You might set yourself to study: bodily proportion; foreshortening; the rhythm of angles or flow of shapes; the way the light falls, casting areas in shadow whilst highlighting others; the varying tones in the flesh; the colours; the actual pose; action poses; weight or mass; props; the relation between model and background; and so on, *ad infinitum*.

In the drawing **above** I am keenest to capture the *overall shape* and *dynamic rhythms* of the pose. In secondary sketches beside the main one, I try to express it more cleanly. Then I find fascination in the feet.

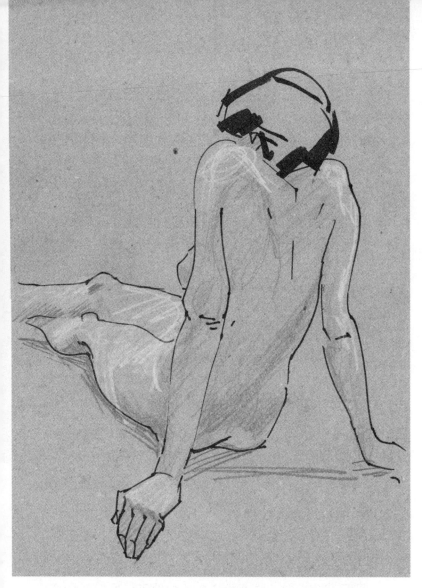

In this quick study, capturing the pose with a felt
tip marker, I get distracted with the flow of the pen
and start to express it all in line. This isn't what I had
intended. So then I swap to coloured pencils and try
to look at *form*/tones of *light and shade* instead.

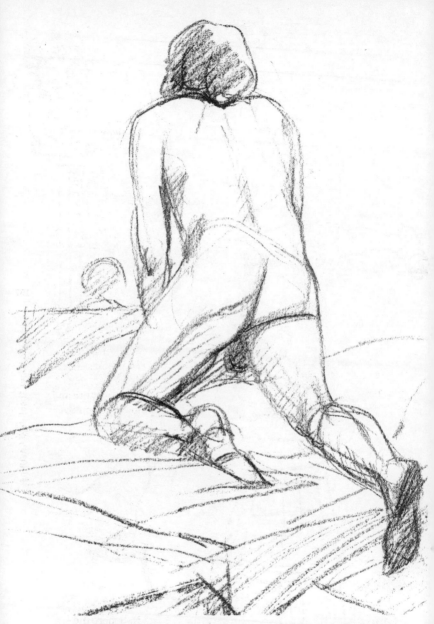

This is a *contrapposto* (counterpoise, or 'opposite') stance, where the alignment of the body is twisted off-axis, usually from the hips, or with one leg balanced at the ankle – the weight unevenly distributed.

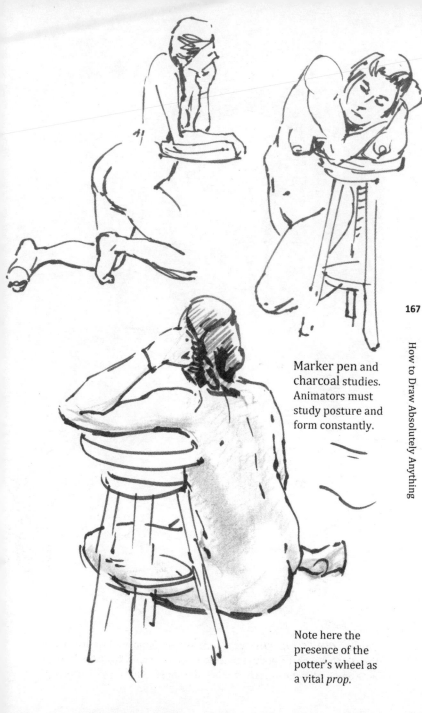

Marker pen and
charcoal studies.
Animators must
study posture and
form constantly.

Note here the
presence of the
potter's wheel as
a vital *prop.*

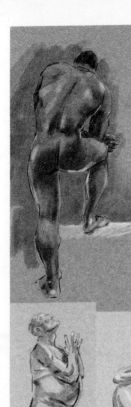

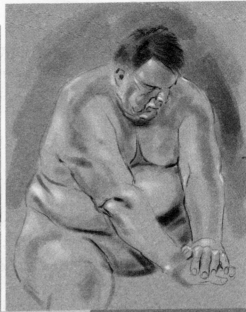

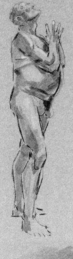

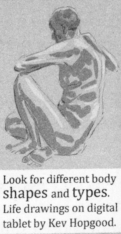

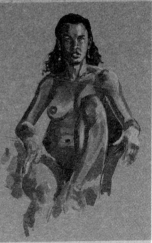

Look for different body **shapes** and **types**. Life drawings on digital tablet by Kev Hopgood.

LIFE DRAWING is hands down the very best possible discipline for improving your drawing skills across the board.

Hiring a professional life model is expensive, so it's more common to gather together with others by joining some sort of workshop. Local sessions in your area should not be too hard to find if you live in or near to a major conurbation. They're even *in vogue* now as a lifestyle hobby – a place to meet soulmates, whether serious about art or not. You don't have to be any sort of a student either ... anyone can go. It isn't always a *nude* model. Some workshops offer costumed themes, such as *Game of Thrones* and *Star Wars.*

But perhaps you are too young yet to join a Life Drawing course, or they are too costly.

There's nothing to prevent you from drawing people in a *public* place. Crowds are good – in a park or at a station. On trains and buses works, although your chosen subjects might object if they spot you. *Art galleries* are a safe bet: people stand or strike thoughtful poses all the time. Volunteer as invigilator for any exhibition and it's part of your *duty* to keep a watchful eye, sketching the while.

You can usually get one or more *friends* to pose for you – especially if you are willing to offer to do the same in return.

These pictures are painted in ink with a brush, utilising the *wash* technique – ink or paint is diluted (mixed with water). More water equals a thinner, lighter wash.

The male figure (**right**) is foreshortened.

LIFE DRAWING – **MOTION STUDY**

No one wants a drawing that is dead on the page, that has no life or any sense of at least *potential* movement. Look *hard*, draw *fast*.

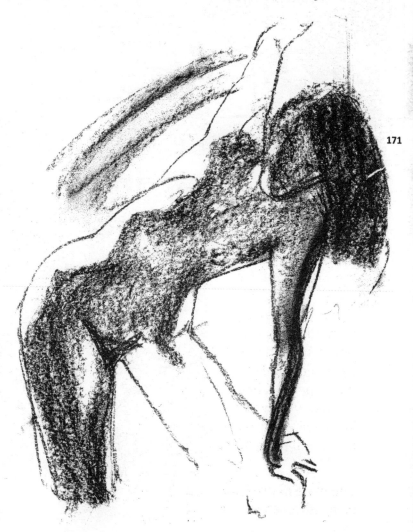

French Impressionist painter (also sculptor and printmaker) Edgar Degas famously loved to depict *dancers*. I wonder, 'Who wouldn't?'

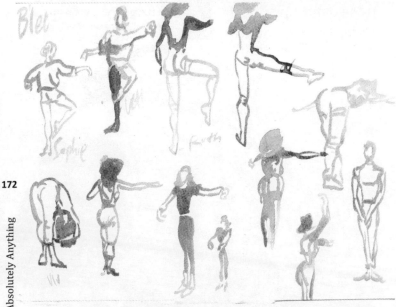

As an art student, I would often sit in during dance classes of various kinds at the nearby Jacob Wells Dance Centre in Bristol, and attempt to capture on paper what I saw (**Above**: ink wash studies of ballet dancers ... Ballet, dear, not 'belly'.) Before too long, I even joined in.

Whatever your own chosen subject for a motion study, keep things loose and fluid. Start to look for the *through line* to any action. As you go on, reduce what you can see to *stick figures*.

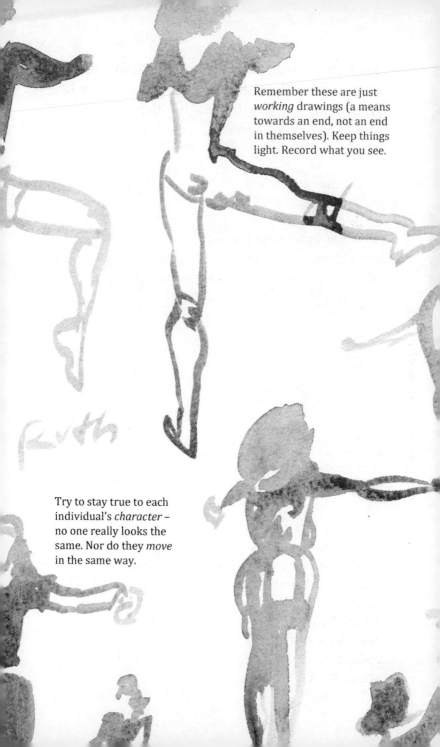

Remember these are just *working* drawings (a means towards an end, not an end in themselves). Keep things light. Record what you see.

Try to stay true to each individual's *character* – no one really looks the same. Nor do they *move* in the same way.

Stick figures don't
deserve their bad rep.
It's actually much harder
to sum up anything well
using the least marks.

As the old saw has it:
Define/Refine/Re-define.

Look hard and long enough
and you will discover the
secret essence to all things.
But can you then *express* it?

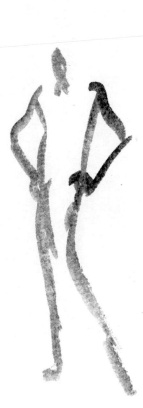

Don't get the idea from this that success is immediate. Honestly? I am *cherry-picking* many of my best shots to put on show here.

You'll have to break a lot of eggs to get your omelette. And you *will* get tired and lose it ...

lost

I'm outta here!

... See?

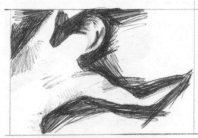

Short of access to life models? You can draw from *photographs* or *screen grabs* to much the same effect. Just be sure to emphasise the sense of *motion* in them.

In these biro (ballpoint pen) studies, the lines of movement or action are extended (**above**) through the repeated stress of shading, like a dark and sketchy *halo* around the figures.

Staying within the body outline this time (**right**), explore form and shape using *contour lines*, as you would find on a map.

These indicate volume, yet also imply direction or flow of movement.

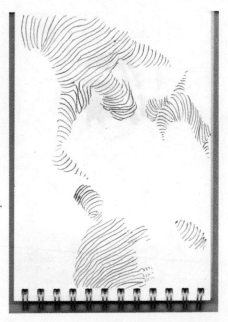

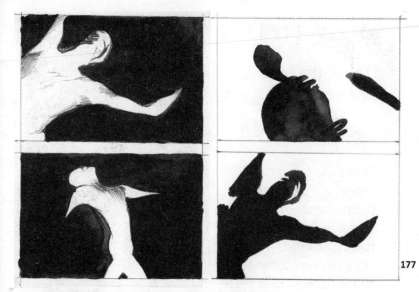

Ink studies (**above**) isolate the figure in space, by either blacking out the background (**left**), or *reversing out* the same high contrast for body silhouettes (**above right**). This is almost like trippy 1960s Op Art!

Finally (**left**), search *within* the isolated silhouettes for their through lines (as seen before with the stick figurines) – the single strokes that all by themselves *epitomise* the very essence of movement (the lines of motion).

How to Draw Absolutely Anything

HOW TO DRAW... **HANDS**

One of the most common complaints I hear in workshops is: **'I can't draw hands.'**

Why should they be so *difficult*?

What I have most often told my students is that it's because there are as many bones in the hand as there are in the rest of the body.

Um, it turns out that's complete rubbish:

> Bones in the hand = 27.
> Bones in the human body = 207.

Still and all, both hands = 54, more than a *quarter* of the sum total, which is enough to tell you that our hands are very complicated.

Think about it: each *finger* is as complex as a limb, with at least as many joints – and each hand has five digits, including the thumb. This makes our hands very *articulate* (expressive, flexible). They are one reason we've evolved and progressed so far, so fast.

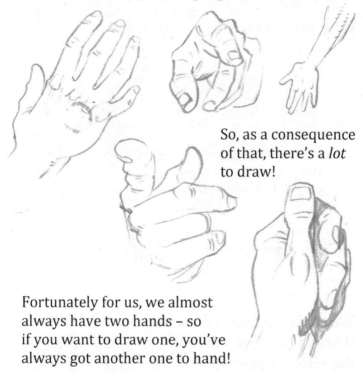

So, as a consequence of that, there's a *lot* to draw!

Fortunately for us, we almost always have two hands – so if you want to draw one, you've always got another one to hand!

You can *strike*, *study* and *copy* hand poses based on whichever isn't your drawing hand all day long. Use a mirror if you need an angle that's hard to position, photograph any pose hard to maintain. If you want a right not left hand, flip and retrace your drawing.

Pay attention to the *size*, *turn* and *angles* of each finger, connections and the relations between all.

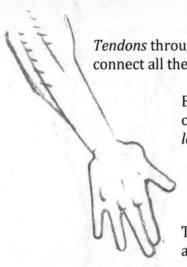

Tendons throughout the hand and forearm connect all the way back to the elbow.

Each finger is of a similar construction, but of different *lengths* (and the thumb, too).

The middle finger is longest, and little finger the shortest.

All of these are important *signifiers*: they show us how the hand operates and make it recognisably a hand. If you don't draw them in, they are missed.

Observing hand poses, check what happens when curling the fingers, gripping large or small objects, pointing, etc.

The sheer complexity of hands is one reason why, when obliged to draw them in the distance, or otherwise at small scale, it's easy to end up with so-called 'spam hands' or 'sausage fingers'. They have to be *simplified*, yet they still need to resemble fully articulate hands.

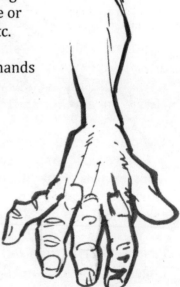

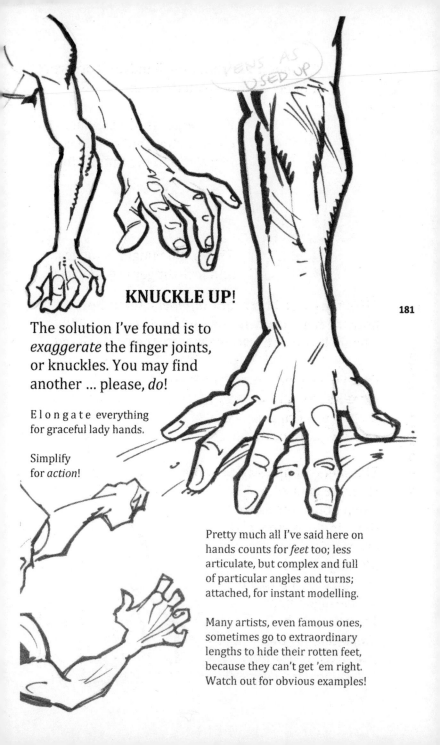

KNUCKLE UP!

The solution I've found is to *exaggerate* the finger joints, or knuckles. You may find another ... please, *do*!

E l o n g a t e everything for graceful lady hands.

Simplify for *action*!

Pretty much all I've said here on hands counts for *feet* too; less articulate, but complex and full of particular angles and turns; attached, for instant modelling.

Many artists, even famous ones, sometimes go to extraordinary lengths to hide their rotten feet, because they can't get 'em right. Watch out for obvious examples!

HOW TO DRAW ... **ANIMALS**

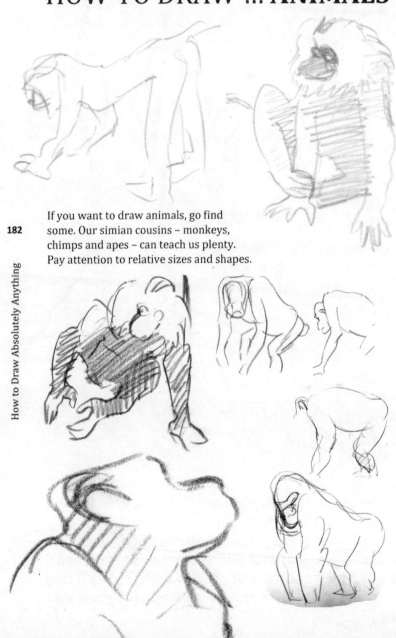

If you want to draw animals, go find some. Our simian cousins – monkeys, chimps and apes – can teach us plenty. Pay attention to relative sizes and shapes.

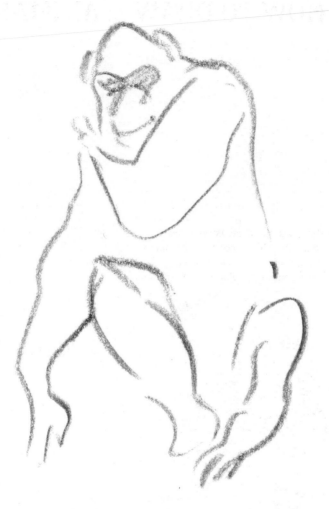

Define/Refine/Re-define

Out of maybe forty to fifty sketches, a whole day's work (and play), you will arrive at one or two that boil down all of your efforts, synthesise them, and say it all in the most simple and direct terms. It may seem like magic or unconscious luck, but you *got* it!

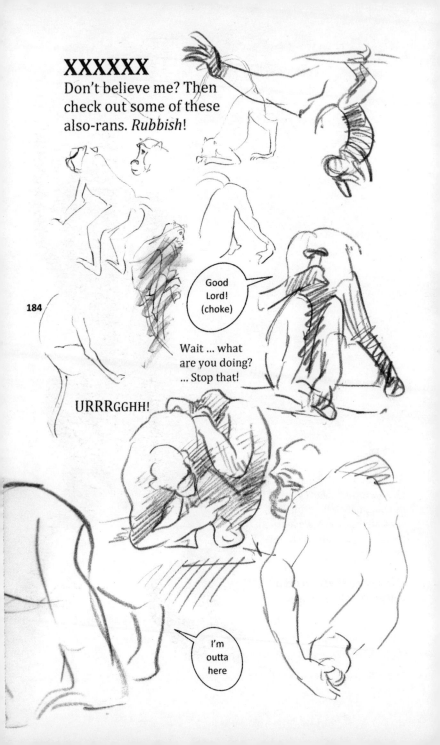

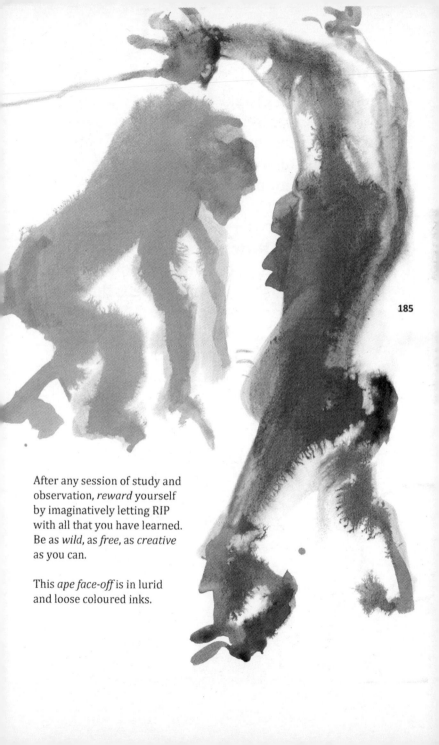

185

After any session of study and observation, *reward* yourself by imaginatively letting RIP with all that you have learned. Be as *wild*, as *free*, as *creative* as you can.

This *ape face-off* is in lurid and loose coloured inks.

MONKEY PUNK – A DAY AT THE **ZOO**

Many artists struggle with drawing animals. The trick is to get *familiar* with them in any way that you can. A trip to the zoo is obvious. You could also drive through a *safari park*, or watch a lot of *wildlife programmes* (freeze-frame and sketch as you need to).

Look for the Differences

Animals most often have a very different set of proportions to humans – knees that seem to bend backwards, longer or shorter limbs, wide or long faces, prehensile tails. Tails! *Hyenas*, for instance, are a truly bizarre mish-mash, all out of synch, out of whack.

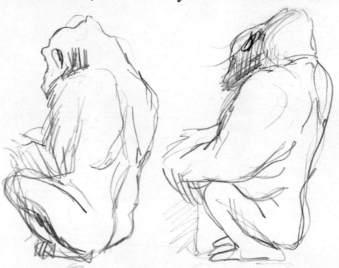

This *silverback male gorilla* is top heavy – all chest and shoulders; low-slung head carriage; long arms, yet much shorter in the legs.

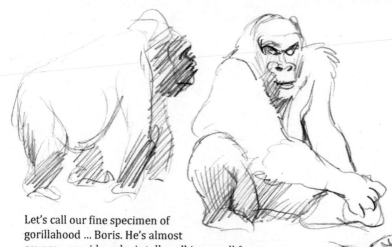

Let's call our fine specimen of gorillahood ... Boris. He's almost *square* – as wide as he is tall, walking on all fours. Hairy, obvs. His feet are like a second set of hands.

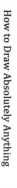

The big belly gives him a low *centre of gravity*. Overall, his size and evident strength lend him *gravitas* – a stately and regal bearing – dignity. (It's a while before he deigns to look my way, acknowledging my presence.) Don't just record the facts, portray the *personality*.

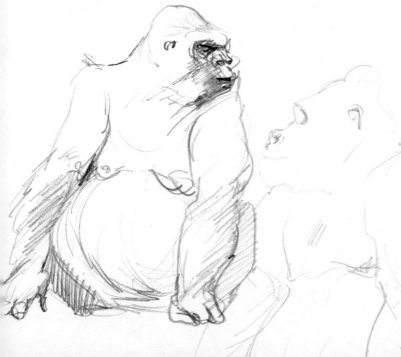

How to Draw Absolutely Anything

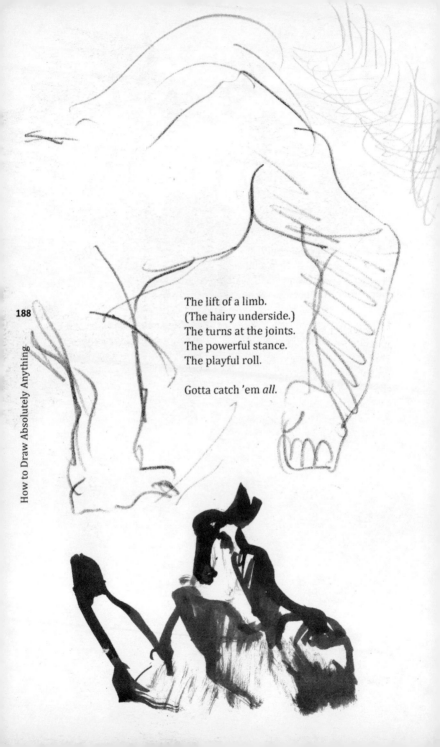

The lift of a limb.
(The hairy underside.)
The turns at the joints.
The powerful stance.
The playful roll.

Gotta catch 'em *all*.

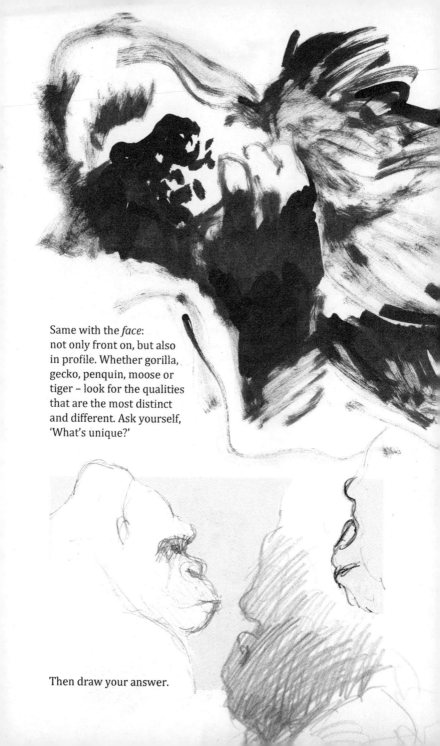

Same with the *face*:
not only front on, but also
in profile. Whether gorilla,
gecko, penquin, moose or
tiger – look for the qualities
that are the most distinct
and different. Ask yourself,
'What's unique?'

Then draw your answer.

(My Family and) **Other Animals**

HORSES

Dogs, cats, *flowers*, *trees* ... the best thing, of course, if you have a yen for drawing any particular subject, would be to consult a specialist *HOW TO* ... text. Walter T. Foster produced these as large-format booklets for decades. I tend to snap them up on sight from second-hand bookstores (I don't really *use* them, as such, but they sure *look* great – classic old-school knowledge and tips).

But, yes, *horses* ... I see lots of duff horse art. They're not easy. Built like a kit of parts. When approaching the drawing of horses, the same basic principles apply.

What's *different*?

I say thee *neigh*.

The head is pretty much all nose. One *big* nose. A Roman one, at that. I have also heard it compared to a *Porsche*.

If there's not one in the bed, I find you can sketch a quick horse head by thinking of it ... as a *kite*.

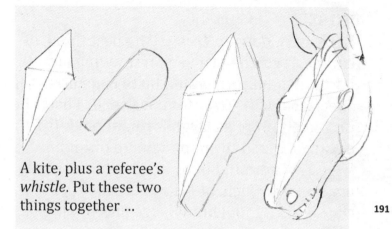

A kite, plus a referee's *whistle*. Put these two things together ...

... and you have the basic outline of a horse's head. Toss in a *mane* of hair and you're there.

The ears are as stiff as carrots, and hyper-expressive with it. Animals of almost every stripe lack eyebrows and, as a result, many facial expressions. So instead they tell us a lot with the various positions of their *ears*, working them like flags in semaphore.

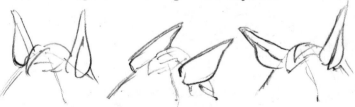

1) Perking up – 'Did somebody say *carrots*?'

2) Laid back flat – 'GRRR! Watch it, Buster!'

3) One forward, one back – 'I'm undecided. Making my mind up ...'

How to Draw Absolutely Anything

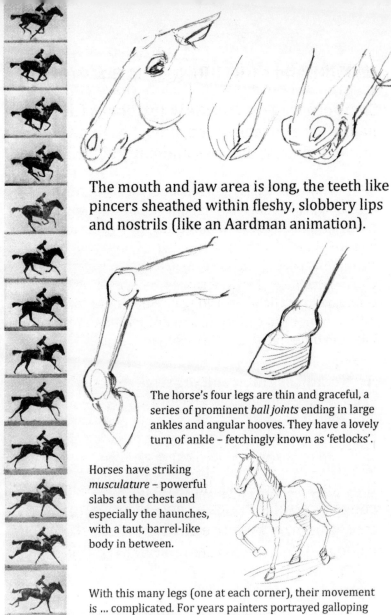

The mouth and jaw area is long, the teeth like pincers sheathed within fleshy, slobbery lips and nostrils (like an Aardman animation).

The horse's four legs are thin and graceful, a series of prominent *ball joints* ending in large ankles and angular hooves. They have a lovely turn of ankle – fetchingly known as 'fetlocks'.

Horses have striking *musculature* – powerful slabs at the chest and especially the haunches, with a taut, barrel-like body in between.

With this many legs (one at each corner), their movement is … complicated. For years painters portrayed galloping horses in full flight mode, like Superman. I used to have a useful set of stencils as a child, to trace out the legs in their many and various positions. The easiest thing here is for you to make a study of the ground-breaking motion-capture photography of Eadweard Muybridge (**left**).

NATURE and NURTURE (but no Nietzsche)

Some other *HOW TO DRAW* textbooks (no names) are concentrated almost exclusively on depicting landscapes and natural forms.

They propound weird and ancient (tho' not entirely arbitrary) rules, such as that one about the 'golden mean', or balancing your subjects and objects in the picture plane – move that tree here, fudge your mountain range over there, in just such a way that you'll produce exactly the same pretty-as-a-picture chocolate box cliché everyone else has since forever. A time-honoured tradition, and not without merit, but ... in quiet need of a NEW Renaissance.

As already established, drawings should best reflect *something* of their subject matter.

HARD
Drawing *machines* and *buildings*, objects that tend to have mechanical, precise edges, suggests *straight* lines – therefore, using the tools that may be more easily controlled, or ruled (no pun: *ruled* as in drawn out by using a ruler).

SOFT
If, instead, you prefer to draw from *nature* – trees, flowers, landscapes, that sort of thing, whether real or imagined – *that* proposes and allows for a more organic, living line.

I'm talking about the sort of line that may be had from the simplest drawing implements, PENCILS (which happen to come from raw materials – wood and clay). Also charcoals, pastels, finger daubs, paints and so on.

HARD? SOFT?

It's all about *favouring*.
Which do you choose?
The HARD or SOFT option?

'If? When?
Why? What?
How much
have *you* got?'

Your natural inclination towards one or the other (chalk and cheese as they surely are, it's unlikely to be both) is fundamental. Your drawings lean whichever way you do. (You can *resist* your natural bent, but this also requires more *intense* practice, and a *steeper* learning curve.) What's most important is that you let your natural drawing skills stay, be, or else become uniquely personal (your very own), rather than generic (the same as everybody else's, or any imagined 'ideal').

That's our goal ... *That's* How to Draw.

How to Draw ... NATURE

Finikas beach, Syros (Greek Islands) by Simon Gane,
www.simongane.blogspot.com

One thing I've noticed about artists of every type is that, as they get older, they begin to take greater joy in the simplicity (or equally, complexity) of natural forms, forms as they are found and observed in NATURE. Besides trees, flowers and landscapes, the rhythms of growth and decay, seasonal change, etc.

One fellow that I know of, his fame and career is based on images of lurid fantasy, outright horror and gore (google Richard Corben). He still draws those sorts of things for his bread and butter, yet he clearly increasingly revels in what would normally be background elements – atmospheric details such as foliage (twiggy forests, leaf shapes), coiling mist, bark and rock formations.

Another, who's made his name from toon rockers and punkettes (google Jamie Hewlett), lately put on a Fine Art show with one entire room devoted to neither girls, nor tanks, but the joy of trees. Sturdy trunks, twisting branches and an endless variance in textures of tree bark.

Above: Another artist (me), another year, a different Greek Island (Logaras beach, Paros). The sunbathers that are for me foreground subjects, Simon Gane (**previous page**) relegates to background detail only … *His* interest lies in the scraggly roots and pine spindles.

One prime, even zen example is found in the seemingly endless *bifurcation* of a tree branch.

(Bifurcation: 'the splitting of a main body into two parts'. See Simon Gane's *Fallen Tree*, **below**.)

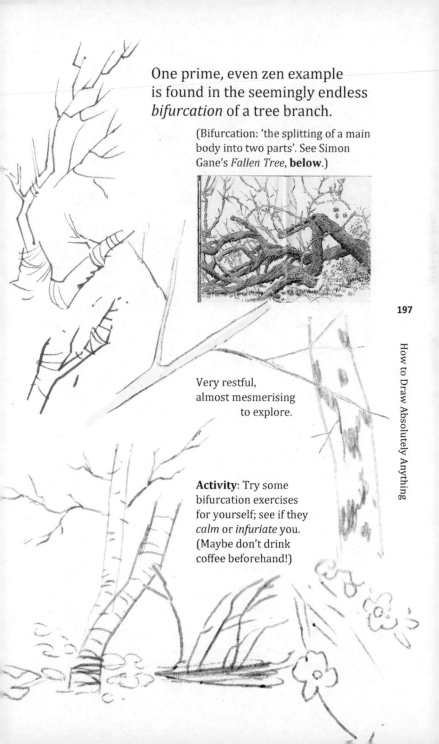

Very restful, almost mesmerising to explore.

Activity: Try some bifurcation exercises for yourself; see if they *calm* or *infuriate* you. (Maybe don't drink coffee beforehand!)

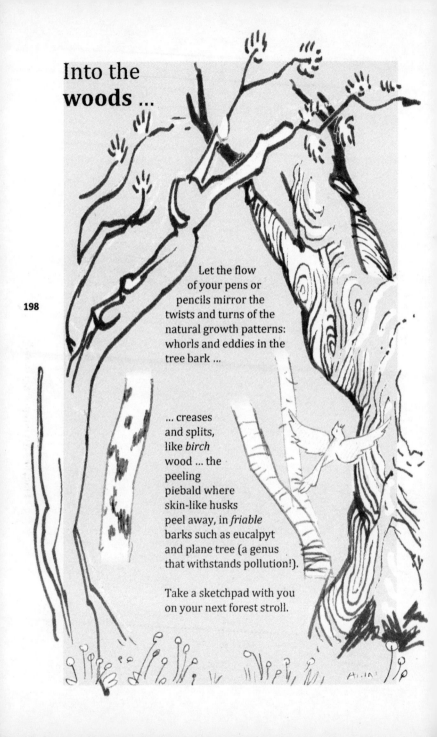

Into the
woods ...

Let the flow
of your pens or
pencils mirror the
twists and turns of the
natural growth patterns:
whorls and eddies in the
tree bark ...

... creases
and splits,
like *birch*
wood ... the
peeling
piebald where
skin-like husks
peel away, in *friable*
barks such as eucalpyt
and plane tree (a genus
that withstands pollution!).

Take a sketchpad with you
on your next forest stroll.

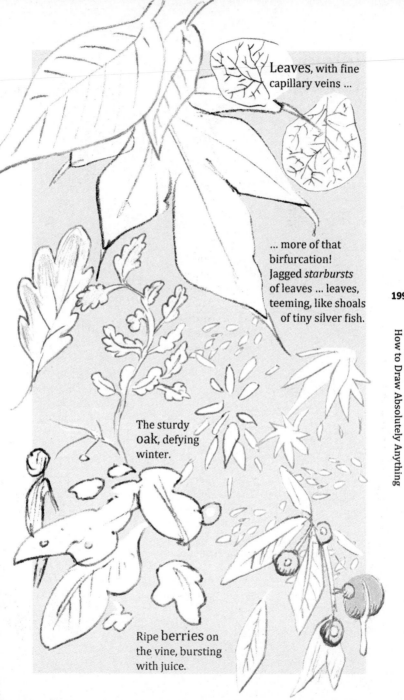

Leaves, with fine capillary veins ...

... more of that birfurcation! Jagged *starbursts* of leaves ... leaves, teeming, like shoals of tiny silver fish.

The sturdy **oak**, defying winter.

Ripe **berries** on the vine, bursting with juice.

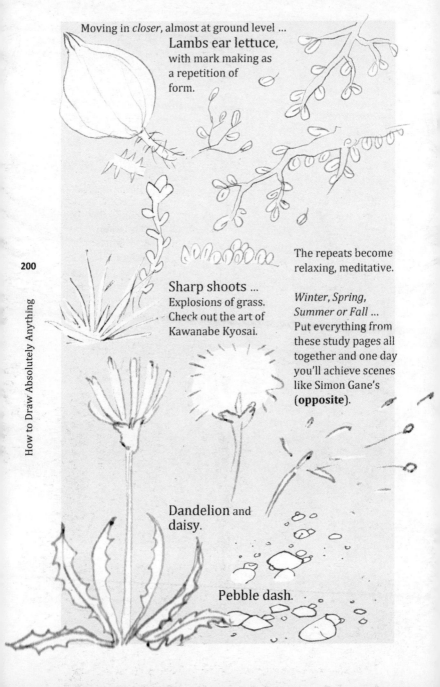

Moving in *closer*, almost at ground level …

Lambs ear lettuce, with mark making as a repetition of form.

Sharp shoots … Explosions of grass. Check out the art of Kawanabe Kyosai.

The repeats become relaxing, meditative.

Winter, Spring, Summer or Fall … Put everything from these study pages all together and one day you'll achieve scenes like Simon Gane's (**opposite**).

Dandelion and **daisy.**

Pebble dash.

How to Draw Absolutely Anything

13 iv 14

Everything begins as a rough *sketch* – a means to an end (learning, improving, exploring, enjoying), and not yet as any self-conscious or artful (artificial) end in itself ('Ooh, look at me, I am going to paint a beautiful tree!').

Although, *cough*, it can be that too ... (beautiful!).

Arashiyama, Japan by Jonathan Edwards
www.jonathan-e.com

It is the sure and steady practice of *one* (sketching, study and observation) that will inexorably lead to the achievement of the *other* (beautiful results).

You don't get to leap successfully, without first doing an awful lot of *looking*.

You could write a book about this *one* drawing. Note how very few lines are unbroken. *Tones* hold things together.

The artist uses his *medium*, brushpen, to reflect his *subject* – blobbing the ink shows us it's muddy.

Areas of *fine detail* are contrasted with *broad black shadows*. Occasional flecks of white paint break these up as necessary.

There's *mud*, and *metal*, a big rubber *tyre* – and even *wood*, all differentiated by drawn TEXTURE.

Tractor by Simon Gane, www.simongane.blogspot.com

TEXTURES are evoked by mark-making, the paper's surface, and the two combined.

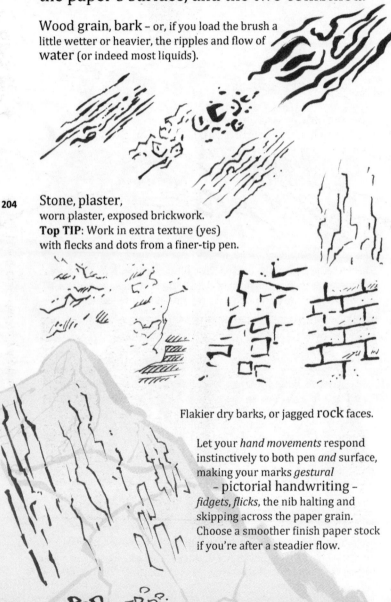

Wood grain, bark – or, if you load the brush a little wetter or heavier, the ripples and flow of water (or indeed most liquids).

Stone, plaster,
worn plaster, exposed brickwork.
Top TIP: Work in extra texture (yes) with flecks and dots from a finer-tip pen.

Flakier dry barks, or jagged rock faces.

Let your *hand movements* respond instinctively to both pen *and* surface, making your marks *gestural*
– pictorial handwriting –
fidgets, *flicks*, the nib halting and skipping across the paper grain. Choose a smoother finish paper stock if you're after a steadier flow.

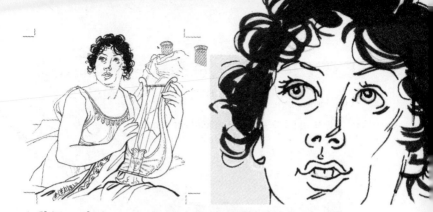

Skin and hair – work with the possibilities of contrast between fine-line technical pen detail (skin), and broad brushstrokes (hair).

The versatile flow of the brush is also often best for *drapery* (fabric in general, as well as the folds in cloth). The flow is texture by itself. Apprentice Fine Artists were once required to study this for *years*.

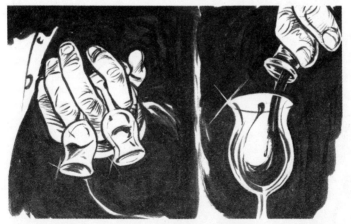

I say, time for a spot of celebration, eh wot? Let's raise a toast to a loaded wet brush for the texture of glass, and light feathering on the fingers to denote the weathered withering of aging flesh ... Cheers!

Hatching, of course, lends texture ...

Changing the length, breadth (thickness), density, direction and/or speed of hatched lines all have their effect.

Here, **right**, two figures meet canalside at night.

Zooming in, we see *dawn* glowing on the horizon. That's whiteout or type correction fluid. Clouds **above**, too.

A thick and waxy pencil might seem a counter-intuitive choice for a light bulb, but its range allows a soft glow, plus contrast in thick shadows behind ...

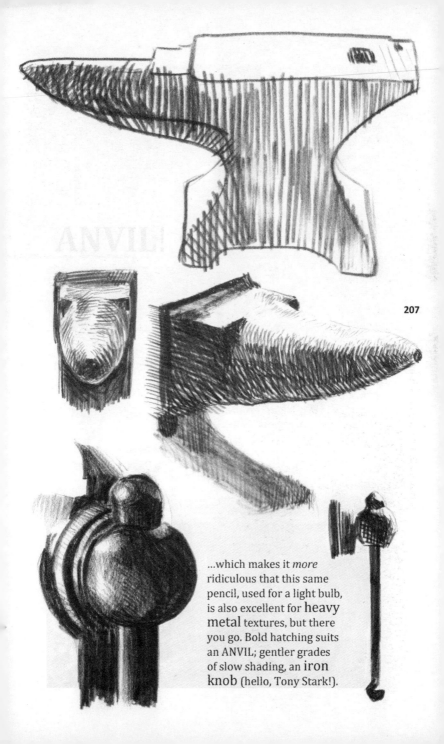

ANVIL!

...which makes it *more* ridiculous that this same pencil, used for a light bulb, is also excellent for heavy metal textures, but there you go. Bold hatching suits an ANVIL; gentler grades of slow shading, an iron knob (hello, Tony Stark!).

Fascination

Automobile

Who loves fast cars? That's right!

If we're talking **metal** textures (and we are), there's none more metal (and shiny) than chrome.

How do we *buff it* to a fine finish?

I actually find a thick and molten liquid lick of the brush works very nicely, most especially when mixed and matched with a slick sweep of thin-line felt tip pen.

Above, left: Another exercise in texture – a clay bust (*faux* flesh and blood), summarised old-skool style in coloured inks. Then (**right**), violinist Paganini (after the sculpted portrait by David d'Angers). This ink drawing is then scanned and coloured digitally, in layers. *Nu* school! I rough tone values first, seeing how light hits it (**below**).

TONE ROUGH

COMPOSITE

TONED LAYER

Think of sculptures as free, 3D life models that never move, found in galleries and museums, always available for unlimited sketching!

You want an **Activity**? Don't kvetch! Go out and etch as many sketches experiencing textures as you think you can stand. Make sure to cover everything – wood, mud, metal, rubber, skin, hair, rock, stone, glass, brick – the works. See what you'll discover.

Meantime, maybe you noticed ... somewhere during our recent exploration of textures we transitioned from SOFT to HARD. Remember about that, back before our *nature* ramble?

HARD is machine parts (like in Mr. Gane's *Tractor*) ...

HARD is buildings (ew), with all of their windows and their awkward right-angled corners ...

HARD is square stuff, with straight edges – or at least hard edges, smooth sides ... all that.

Worst of all, HARD stuff is stuff where people can usually tell (and will very often say!) when it's not in 'correct' PERSPECTIVE ... AAGHH!

HARD is ... hard for me. HARD is so *not* my 'natural tendency'. Increasingly, I'm becoming a nature boy – guess that means I'm getting old. What I favour, very much, is the SOFT option.

CARS and BUILDINGS? *HARD*! ... They're my garlic.

So let's go right ahead and sample some of that hard stuff, more than a drop. Because this is *HOW TO DRAW ABSOLUTELY ANYYTHING*, innit!

STRIKE HARD!

THIS WAY ...

How to Draw Absolutely Anything

AGAINST NATURE

I went through my files, looking for examples of Good Car Art I had drawn – found quite a few – but many were clearly based on photographs of actual cars. The best they could be is impressively *realistic*. Whatever that means.

Should the image of a car have to appear realistic, to make for a car that convinces? I would say, if that is what you want, simply take a photograph.

What more *is* a car, really, than a box on circles, with holes in it for windows or doors?

So long as a drawing communicates 'car', job done.

Or perhaps you want more.
Reality, however, is overrated.

Activity: Perhaps in your next drawing, allow yourself to imagine an entirely *new* design for a car.

How to Draw Absolutely Anything

HOW TO DRAW ... **IN PERSPECTIVE**
Should you really *want* to, that is.

Perspective, *aka* Point Of View (P.O.V.) –
what you see according to where you are
looking *from*. Featuring:
The Truly Baffling Case of
the Phantom Flying Chair.

The grey line (**below**) represents
your eyeline (your perspective).

Going from left to right:

When you are roughly *level* with the chair,
perhaps slouched on the sofa opposite, you
will be looking down on it from somewhere slightly above (it would
be higher, and at a more extreme angle, if you were standing).

Get down and crawl on the floor now. Your head is *below* the height
of the seat of the chair.

Finally, an odd worm's eye view – perhaps you are climbing stairs
and can see (a partial view of) the chair in a room above. Or maybe
you live in a fancy loft conversion with glass floors, I don't know.

Basically, you are *way* down low below the chair.

All lines of sight will eventually lead to a vanishing point on the horizon (same as your eyeline).

The chair fell over.

The angle at which we see the chair, if stood directly behind it, is dictated by its relation to the vanishing point of our perspective (anything straight up still goes straight up). This is a one-point perspective.

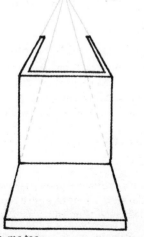

Struggling a bit? Yeah, me too.

Here's a one-point perspective of a street scene.
(The Old West on the left, a modern cityscape on the
right. Progress, right?) It's a little harder to draw but
actually easier to get a handle on. Darn tootin'!

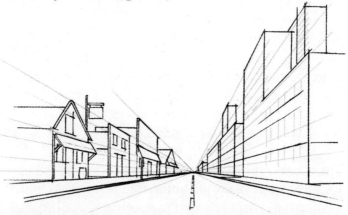

Objects appear *smaller* the further away they are
from our P.O.V., as they approach the vanishing point.

Move to one side or other of that chair, or away from
the middle of the street/turn towards the corner,
and you gain a two-point perspective.

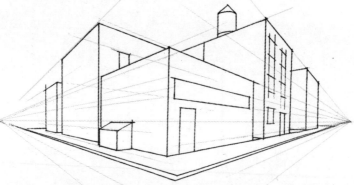

The two vanishing points relate to the two *sides* of the object that
you now have in view. It feels like the buildings are coming towards
you, as well as receding into the distance on either side.

Here it is again with the chair.

To get to the drawing of your subject in perspective (the black line), you first have to do all of the measuring and construction drawing (the grey lines), using a ruler. That takes up time ... and space!

There's also three-point perspective (from further above or below), but do you really want to go there? If you should find yourself properly getting into the subject, other books will go into it in more depth.

Here's *my* perspective on it:

After all that I felt so exhausted I had to go lie down in the corner ...

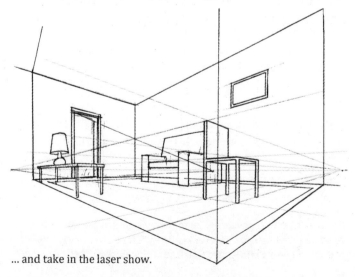

... and take in the laser show.

An Aside ... My Own Perspective

I would question, does perspective absolutely always have to be correct? (When it comes to drawing, accuracy and realism are – for me at least – automatically less interesting, both as a practitioner and as a viewer.)

Ten people drawing a scene in correct perspective will produce fairly similar views. As I've expressed before, if we all drew to the same average, there'd be no point anyway and not much worth looking at.

All my life I've had the rulebook drummed into me, to the point where I have to work that much harder for my drawings *not* to come out – well, if not realistic exactly – as *naturalistic*. My drawing ability is praised and my drawings may convince, but that perceived quality makes them so much *less* interesting to me personally. It's not what I'm after.

I'm working hard now in my advancing years to find my way back ... back to my instinctual *nature* instead of this false 'nurture' ... back to seeing things, and drawing things, in my very own particular way.

You may well be there already, with no great need to learn or unlearn anything – regardless of whether you actually feel that way, or recognise it. Cherish the individual quality in the drawings that come to you the most naturally, and try not to lose sight of it.

Don't lose perspective, to gain perspective.

There are other less taxing or mathematical ways to suggest perspective or depth of field (depth perception) in your drawings.

Or, having tried it out for yourself, hopefully understanding the basic *theory*, you could just roughly estimate by eye. I do.

Drawings are *2D* – two-dimensional, OK, *flat*. (Sculpture is *3D*, and time, *4D*.) You create the *illusion* of space, fooling the visual sense of orientation – using *foreground*, *middle ground* and *background* perspective.

Foreground Middle ground Background

Objects or persons in the foreground are closest to the P.O.V.; in the background, they're the furthest. The middle or mid ground is whatever's in between (maybe nothing, only space).

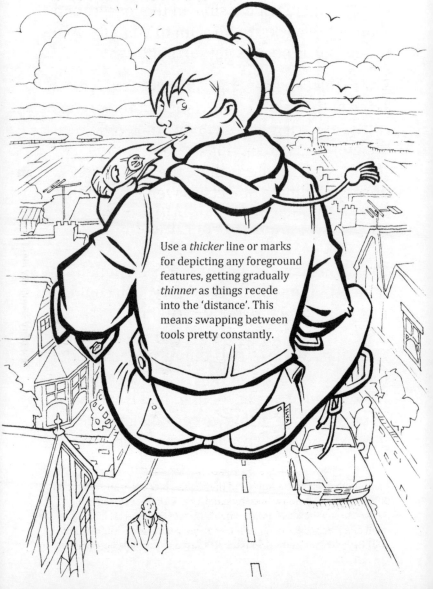

Use a *thicker* line or marks for depicting any foreground features, getting gradually *thinner* as things recede into the 'distance'. This means swapping between tools pretty constantly.

In case you're wondering ... that floating girl (**opposite**) is Miss Jean Genii. She discovered a real live *djinn* trapped in a can of firm-hold hairspray who granted her three wishes. Her first wish transformed him into a pizza (she was *hungry*!). True story.

More *detail* may be visible in the foreground than in the background. Aim to simplify your rendering as objects get further away.

A way to keep drawings alive is to carry over some of the sense of movement and perhaps a little electricity, or alchemy, that you've hopefully picked up during your *motion studies*, or elsewhere along the way. Apply this to inanimate objects as well – those that most commonly form the HARD stuff (**below**).

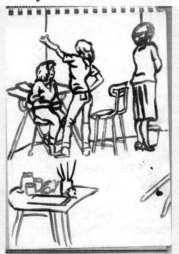

Treating the rest of the room and the various bits of furniture in it no differently (just as loose and freehand, and with the same brush – *wobbly*, to say the least) unites environment with figures, making them of a piece (bear in mind such *harmony* may be the opposite of any effect you wanted for yourself: it's just one possible approach).

HOW TO DRAW ... **DIFFERENTLY**

Here's some other magic tricks, not a million miles removed. We'll make these an **Activity**:

Randomise your encounters!
Try drawing with a deliberately *loose* grip, the pen or pencil almost dangling more than held in your normally pincer-like grip.
Let the tool to an extent take the lead, or struggle more than usual to follow yours.

SOUTHPAW GRAMMAR
Taking this even further, next, try drawing with the *opposite* to your dominant hand – so if you're right-handed, use your left; and if you're a leftie, then swing to the right.

Opposite: An awkward drawing, executed with my left hand, of what was then our front door.

These methods remove an element of your *control*, which can otherwise pre-suppose outcomes. They allow chance and accident perhaps to enter into the picture. They may well seem odd, yet are strangely liberating, and could eventually lead you and your art to some entirely awesome new places ...

... STEP through the doorway. You could end up with a whole range of new drawing styles.

A **cityscape** might aspire to be HARD – all clean, sharp lines and dizzying, vertiginous perspectives – but how often are they *really* like that? Cities were made to be lived in. And sometimes, they can look it ...

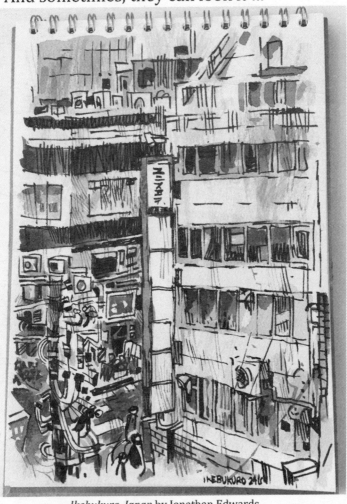

Ikebukuro, Japan by Jonathan Edwards
www.jonathan-e.com

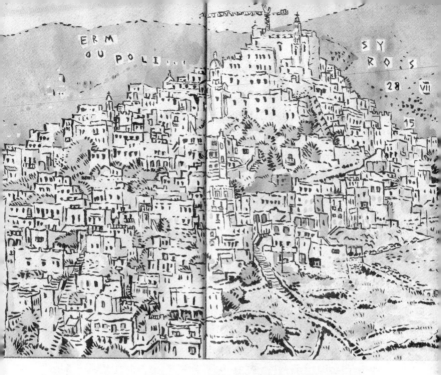

Delicate wash tones from a *limited palette* (not too
strong in contrast, lest it overpowers) lend clarity
by demarcating the rising ranks of adobe structures,
interspersed with sparse and spiky vegetation. But
they also go some way to conveying the bright, direct
light and heat of the Mediterranean sun – allowing
the blank white of the page still to make its own
eloquent contribution. Repeating yet variegated marks,
suggesting window after window, walls and shrubbery,
plus other shapes, build their fascinating rhythms
– not frenetic, but calming, spellbinding, inviting.
Don't you want to climb those tempting glimpses of
rising stairway? Don't you wish you were *there*?

Lasting memories more personal than any postcard.

Ermoupoli, *Syros*, by Simon Gane
www.simongane.blogspot.com

THROWING **SHADE**

We've looked at feathering, hatching and so on; how flecks and stipple marks can help to define shapes and surface characteristics of what you are drawing, suggestive of textures from flesh to bark to glass. Also, indicating *mass* – the weight or volume of something. Which is heavier, the drawing of a feather or the drawing of a lump of coal?

This brings us to SHADING.

Building up layers or density of hatching – starting from light, progressing to dark – you can *gradually* shade in anything, of course.

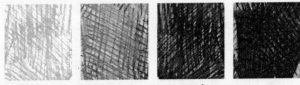

You make use of visual contrasts between areas of different intensity as *modelling*, to form the shape of your subject, whatever or whoever it might be.

But what if you had to do all of this using only *solid shadow*? In this case, black?

(The lighting effects of shading and shadow work just as well of course in *colour* – the Impressionist painters revolutionised art with their explorations of that – but this book is printed only in black ink on white paper: monochrome. Bear well in mind that all I say here concerning shading and shadow might also be interpreted in colour, even if I have to show and tell strictly in terms of black and white.)

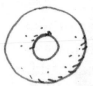 Hey, remember that crazy ring *donut* we did, with the sprinkles on it and everything? Only, I could swear somebody mentioned **bagels**, and now I totally want some of *those* instead ...

Wholemeal, preferably. They have like so much more texture.

OK, I can't keep that up – see (**right**) how some stippling and hatching adds to the simple image, lending form and dimension.

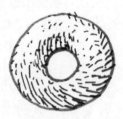

But, if instead we increase contrast and drama in the notional lighting, throwing half of our shape into deep black *shadow*, the same idea is even more definitively expressed.

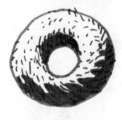

When lit, objects also cast their *own* shadows, as seen in the following ...

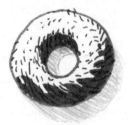

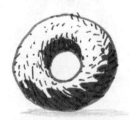

In the first image (**above**), the bagel lies flat and is 'lit' from the side. Standing it on end (**above right**), if lit from above in a high-noon style, the shadow is cast underneath. Or it is longer, and fades out, if lit as before just from one side (**right**).

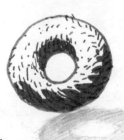

Shadows usefully *ground* your drawings.

Over a line drawing illustration, areas of *black* are added for greater definition of form, casting shade or *as* a shadow ...

Black ink *shine* suggests the metallic quality of the bucket (**above**), but also its curved shape and dark interior.

Half in shadow (**left**) is a cool as well as dramatic means of defining form.

Working back into the shadow with reflected light (inner thigh at **left**, as on the bucket **above**) can also be highly effective. Also note the *cast* shadow from one leg falling across the other.

Breaking up the black areas with detail in white (**left**), or fading them out (**right**) may also serve your purposes.

Counterpoint, alternating from black to white and back again, is a strong look.

You can use it even *within* a form, such as the pole of this lamppost (**right**).

Again with the half-shadow (figure, **left**) to emphasise the tilt of the whole body and the direction of the action.

And again with the black-white-black counterpoint (sponge scene, **below left**).

Activity: Photocopy or scan some of your own line drawings and try out *shadow-boxing* – adding shade or shadows.

Come on, you can't back out now.

You may find that you want to add shadows for all sorts of reasons.

Not least among them is DRAMA ...

... a heightened sense of *emotion*, *suspense* and/or *tension*.

Learning where, when, why and how to place the contrast of shading and/or shadows is sometimes called 'spotting blacks', and is an art in itself – which is why I say *practise* on photocopies ... you can't just phone it in (sorry).

Another good reason to go there is MOOD ...

Lashings of *atmosphere*. Nothing better on a
dark night than a little *noir* or horrorshow.

Filling in the midnight-dark sky with loose brushstrokes rather than
a solid black mass somehow *adds* to the flow of disturbance in the
image – we can almost feel our guts churning. The air itself is *alive*.

Note as well the spidery filaments of the bare tree, picked out partly
in white against the black, or running counter to the hatched surface
of the building beyond. Even railings on the roof can just be made out.

So far, so definite.
But to close out
this section, here's
another *what if* ...

Perhaps, if you're
enough of a *kung fu*
nerd, you've heard of
the Art of Fighting
Without Fighting.
What if you could draw
... without drawing?

Your artwork can be just
as much about what you
DON'T draw, because it's
also about what people
see, whether or not it is
actually (drawn) there.
Our brain Is trained to fill
in blanks or *omissions*, to
decode and satisfy itself.

I refer you to the smoke,
mist and cloud stylings
of Japanese ink-master
Kazuo Koike: also, Gene
Colan – semi-distinct art,
perfect for atmosphere,
for motion, action, drama.
Viewing their work is a
properly interactive and
therefore more *personal*
experience, primarily for
the viewer, but, equally
so, implicitly gifted from
and therefore also *for* the
originating artist.

Collaboration or collusion,
certainly *communication*,
and wholly communion.

An Aside ... *I AM (NOT) A CAMERA*

When taking life as our subject – drawing from life, not our imagination, which is another kettle of eels – then our object, as with the results, should not be an attempt to replicate *exactly* what it is that we are seeing. That would be impossible ... but also faintly pointless. Why even strive for that when you can do it to explore your own individual perception of our surroundings, including how they affect us – along the way discovering how to express, and succinctly, what it is to be and feel alive, right here, right now.

Any drawing, every mark made, is in response – an *interpretation*, inspired by nature or whatever else it is that we are looking at and witness to.

Such observation and faithful recording may yet be achieved with illustrative flair, a flair more effective than any photographic or photo-real fidelity. That's not what drawing's about. Otherwise, use a camera.

Take a photo, it won't last as long. By which I mean, there's automatically less to it. Less concentration or study. Less sense of singular achievement. Less to cherish, long-term. I can hear the photographers now, objecting, tempers fraying. Yet even they have to admit that they condense their skill and years of study and experience into the work of split seconds. Plus, with phone cameras, we can all be top shutter-bugs these days ... Wow, now I can *really* hear them! Snap, snap, snap!!! (heh, heh, heh.)

'I am a camera with its shutter open, quite passive, recording, not thinking.' – *Goodbye to Berlin*, Christopher Isherwood

HOW TO DRAW ... **FROM PHOTOGRAPHS**

I wouldn't overly advise it. 'Tis a filthy practice but it does go on and it can sometimes serve a purpose.

Too close an adherence to the source risks draining all *energy* from your drawing. To help ensure against this, I strongly advise that you do the following:
Working from the photo, draw a first draft, taking on just the bits that you want. Discard the photo, then redraw (a new drawing), adapted from your first effort.

Honestly I've done this and the results are much better. Or you could *trace* the photo.

Even better, if you also *took* it!

Opposite: *Danielle* – I'm actually happy that I drew this, and pretty faithfully, given all of the above, since I lost the original photograph (which I also took) a loooong time ago.

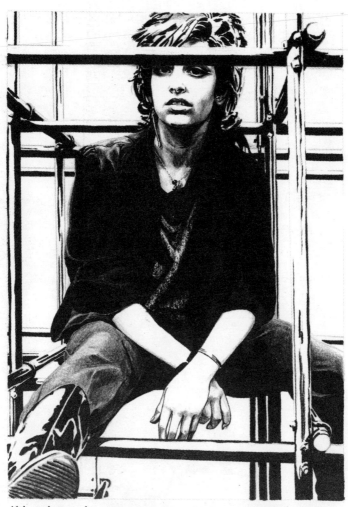

Although traced, I'm maximising the *advantage* any adapted drawing has, by upping the contrast, making especial emphasis of the different

textures – on the sweater, the trousers, the boots – even her skin.

There *are* aspects from photography that you can take on in your drawing. Most camera lenses, cinema included, cannot focus on both foreground and background at the same time – when they shift from one to the other in-camera, they 'pull focus'.

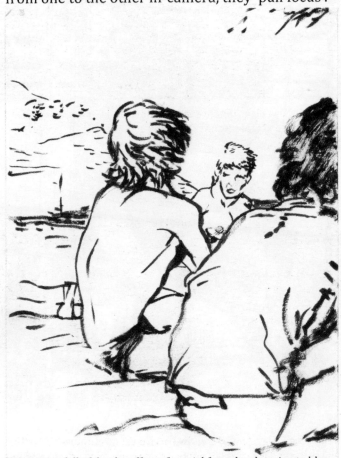

You can usefully fake the effect of partial focus by choosing to blur either your foreground or your background elements. In this beach scene (**above**), the figure in the immediate foreground is *blurred* by using a dry brush. If we're being generous, we could say the spartan background also lacks focus. We effectively *pull focus* on the person in the middle (Hi, James!). Drawing effects based on photography.

Same here in a night-time scene canalside. 'Out of focus' bullrushes in the immediate foreground frame the action across the water.

I can't even begin to explain how I arrived at this (**above**), other than to say it was a complicated puppet-show performed on a photocopier *while it scanned*. But, this is basically *time-lapse* photography by hand-drawn means. In cinema, a *montage*. All day long by the canal, just cyclists and a fisherman passing through. (**Behind**): the original drawing that makes up the background. Lovely bit of hatching!

HOW TO DRAW ... **CARTOONS**

Cartooning is *The Art of Simplicity* – taking any subject and breaking it down into simpler terms, to better convey it. Cartoons don't have to be funny, though it often helps. This is especially useful when something's complicated or otherwise difficult to digest. Think of plug-wiring diagrams and aeroplane safety leaflets. Many health messages come in cartoon form (**above**: sketch for proposed leaflet concerning arthritis in teens). It's another variation on the idea of Define/ Refine/Re-define – breaking an image down in order to (re)build it back up again.

What's a good example of cartooning? It's this *ear* ...

Take a realistic sketch of the human ear. Try to express it in fewer lines. Once you have worked out a simpler version, this can become your standard *cartoon* shorthand for an ear, almost like an @ symbol. You can apply this cartoon simplification to almost anything. TRY IT!

Drawing ears *as* ears, realistically, is so very difficult as they are such a complex rhythm of interlocking shapes (ear-prints are said to be more individually unique than fingerprints).

ICONOGRAPHY
With cartooning, you can reduce anything to its basic building blocks – often coming up with your own individual and highly original solutions during the process. Stylistically speaking, anything goes – if you can make it work (have it communicate), then it works!

Gary Larson, Bill Watterson, Ron Rege, Paul Grist ... With the best cartoonists, their stripped-down, iconic representations of cars, trees, etc. are instantly recognisable hallmarks, part and parcel of their own individual styles. Whatever they should choose to draw, their idiosyncratic signature style will still be all over it – unmistakable!

THE ART OF **CARICATURE**

Likewise with caricature – look to identify and then zone in on defining characteristics. Isolate, emphasise and exaggerate them out of all proportion.

Take, for instance, Simon Cowell – what comes immediately to mind?

Certainly, the high-trousered waistband. The form-hugging jersey cardigan (brrr!). I see almost everything about him as a square. So I make him, literally, a big *square*. A blockhead.

Isolation, emphasis and exaggeration.

(Not sure what a wee G.W. Bush is doing there. His little face is lost on a large head with giant ears.)

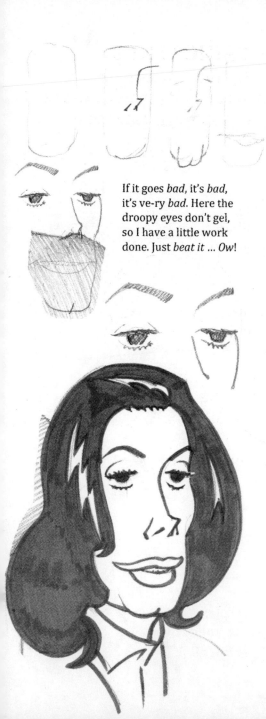

So, *you wanna be startin' somethin'*? First, break it down.

WHO IS IT? Decide on the overall shape of head or face. What are their most prominent features?

If it goes *bad*, it's *bad*, it's ve-ry *bad*. Here the droopy eyes don't gel, so I have a little work done. Just *beat it … Ow!*

How to Draw Absolutely Anything

Whoever it is, try to get *behind the mask*.

Don't stop 'til you get enough … until you've created a real *thriller*.

(Yes, that's right, fact fans, I've drawn … Elizabeth Taylor! No, wait … that's not right …)

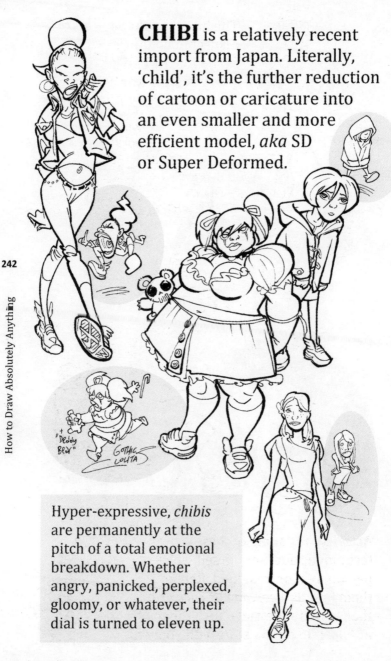

CHIBI is a relatively recent import from Japan. Literally, 'child', it's the further reduction of cartoon or caricature into an even smaller and more efficient model, *aka* SD or Super Deformed.

"Daddy Bear"

GOTHIC LOLITA

Hyper-expressive, *chibis* are permanently at the pitch of a total emotional breakdown. Whether angry, panicked, perplexed, gloomy, or whatever, their dial is turned to eleven up.

How to Draw Absolutely Anything

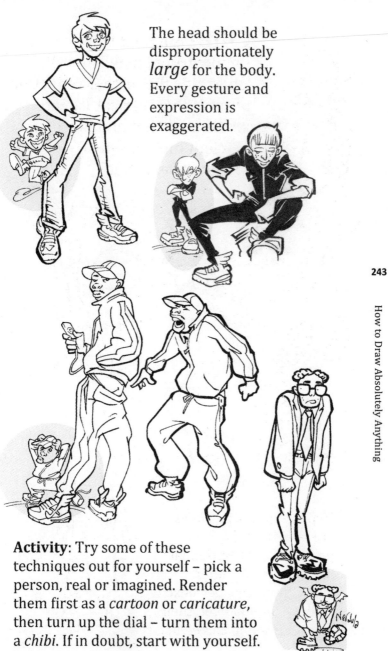

The head should be disproportionately *large* for the body. Every gesture and expression is exaggerated.

Activity: Try some of these techniques out for yourself – pick a person, real or imagined. Render them first as a *cartoon* or *caricature*, then turn up the dial – turn them into a *chibi*. If in doubt, start with yourself.

OFF MODEL – and LOVING IT

'Holy *hell*', you might be thinking, 'those are some *rotten* cartoon drawings!'. And you'd be right! But then, this is (drum roll) ... The Cartoon Character Challenge!

As Jessica Rabbit says in *Who Framed Roger Rabbit*: 'I'm not really bad, I'm just drawn that way.'

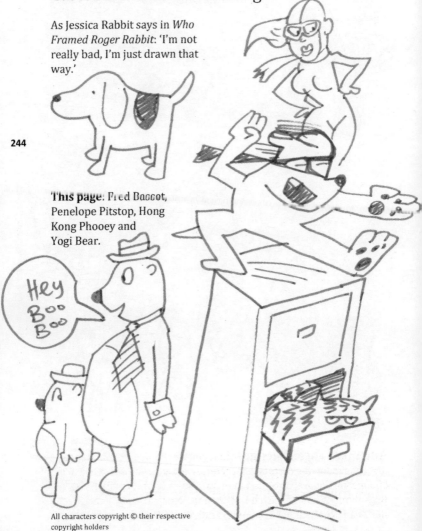

This page: Fred Basset, Penelope Pitstop, Hong Kong Phooey and Yogi Bear.

244

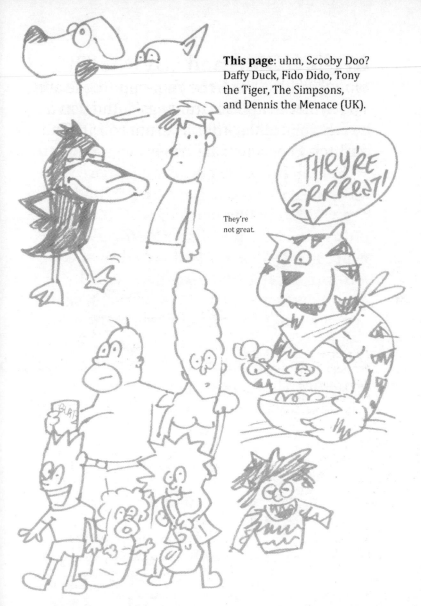

This page: uhm, Scooby Doo? Daffy Duck, Fido Dido, Tony the Tiger, The Simpsons, and Dennis the Menace (UK).

Activity: The challenge is that you have only two minutes to draw the following cartoon characters, *without* using *any* reference: Spongebob Squarepants, Bananaman, Jessica Rabbit (yes!), Hulk, Bugs Bunny, Snoopy, Pikachu, Marvin the Martian, Beavis and Butthead. No cheating! Try it with friends and *new* character lists.

GRAPHOMANIA – not to be confused with GRAPHOTISM, the long-running Graffiti and Street Art publication – is defined as a psychological disorder associated with OCD and schizophrenia; the obsessive impulse to write*. I'd probably peg it somewhere in-between language (lang gwij**) and drawing, including much of *graffiti*'s verbal plus visual tics, as well as new forms of expression (such as ASCII art); drawn letterforms, real and imagined (actual alphabets, *kanji*, adapted or made-up signs and symbols). In other worms, eel free, make up whole words, **nonsense homophones, deliberate misspellings, grammar, sentence structure, rhythmical lines like those on a seismograph, logos – illustrwriting pichaws.

Activity: If a word should obsess you, whatever it is – RABID, *JOY*, PLANKTON – look for as many verbal as well as visual, or visual AND verbal, ways as you can to embody and express it.

* Think that you might have this, even a little? If so, you're far from a loon. Dostoevsky, Lewis Carroll, Van Gogh all showed signs of it in their sketchbooks.

ABSTRACT EXPRESSIONISM

Whether or not you feel you might be any sort of GRAPHOMANIAC, always remember that what you're doing is a *drawing*. It's not a photograph (you are not a camera), not an animation either, but *your* drawing. In your drawing you have complete control over all of reality, to the extent that you may create your *own* reality if you wish – the mood is entirely up to you. The atmosphere, also the emotional resonance, be it angry, joyful, sad, weary or whatever – all of this affects and is affected by your mark-making.

That especially includes any *abstract marks* you might make. These are marks that don't by themselves necessarily have to mean, or represent, any thing – not any real thing. They're an abstraction.

In effect you are allowing yourself to draw what isn't there: you're doing a drawing of what's *not* there – except you *put* it there. Acting out through your drawing in this way is an essential part of your self expression.

THE INNER CHILD

If you ever hear these sorts of catcalls, in the playground, at the office, at an art gallery, or even just inside your own head, IGNORE them. Reframe the notion that you draw like a kid (or even frame it!). It's a *good* thing.

Even the most established artists want that for themselves – to *unlearn* all of the reflex action, negative energy or outside influence that they've picked up and taken in over the years – to find their way back to something pure, simple and direct: a unique perspective that remains unspoiled (un*adult*erated!).

Pablo Picasso once said, 'Art washes away from the soul the dust of everyday life.' (One of the smartest summations I've ever heard.) And here's *another* famous quote of his:

'It took me
four years to paint
like Raphael, but a
lifetime to paint
like a child.'

Picasso, possibly the world's most famous artist, isn't judged harshly for his pure lines and childlike simplicity. He's celebrated, and rightly so. By learning to strip things back to the basics, expressing their essence through the primal joy of mark-making, he managed to put himself in touch with the universe and his place within it.

Jack Kirby and David Hockney, likewise, were able to work themselves into this same hallowed zone, opening up gateway portals, as it were, to a whole other level – alternate realities of their own making, that used building blocks from this universe to reinvent or even create *new gods* and a *new* universe.

'It just makes
you want to draw.
Every page [KIRBY] did is
infused with energy, with his
spirit. Dynamic, inspirational.'

An Aside ... COPYING

'Copying before undertaking your own
creations is a natural process.'
– *Hur Young-man*, bestselling Korean artist

It is fine to copy images as a youngster when
starting out. You can learn much in this way.
The roles of mentor and apprentice exist in
almost any trade or field of craft.

If, however, you are older than about 17, 18,
or by the time you reach this sort of age, try
not to copy so much any more – unless you
have never really tried drawing regularly
before, in which case, aim to move away
from copying after your first year or so.

It would be all right still to copy another's
artwork for study, on occasion, with the aim
of synthesising what you may learn into
your own practice, your own style – but,
unless you eventually leave this behind, you
will never develop your own original style.
You won't be able to declare your artworks
entirely your own. You might never know
or feel that intense satisfaction.

And that would be a shame.

GROWING IN **CONFIDENCE**

Even a Michelangelo or Leonardo hates their own drawings: everybody does. It's (im)perfectly natural – if you didn't, there might be something slightly wrong with you.

You can see it in your head and it looks great, but you simply can't get it down on paper and also have it look exactly how you wanted. It is this nagging doubt, this maddening quest, that is the very *spur* that goads us on …

... we're all dreaming the impossible dream, chasing a pot of gold at the end of a rainbow.

Perhaps this feeling of *constant frustration* is actually for the best. After all, if we ever *got* there, where everything was exactly how we wanted it to be, then we'd probably give up. Why strive, when you have a pot of gold!?

Another truism is that when looking at any drawing you've made, others will see only what's *right* with it. You, however, will see only what's *wrong*. That's worth repeating: only *you* see or think that it's wrong.

CONFIDENCE TRICKS

There are various fairly simple tricks that you can try, to overcome confidence issues around your drawing ability.

Pretend to be assured, even when you are not. This is the same as walking into a room with your head held high, in spite of any nerves you might feel. Amazingly enough, it really works! Even if you think you have no real clue what you are doing, or how to draw something, *commit* anyway to drawing with a firm line, making strong marks. This alone can make all the difference.

As obvious as it may seem, it was a *big day* for me when I first realised this. I've been trading on it ever since. Some days I even convince myself that I know what I'm doing!

Take yourself out of the equation. This doesn't have to be about *you*. Make your next drawing assignment (and as many as you wish to after that) into a thoughtful present for someone else – a loved one, friend or family. Think of a person, your recipient, and then consider what sort of drawing, and of what subject, *they* would *love* to receive. Make that, and give it to them – whether or not it might be their birthday, or Christmas. In such rampantly commercialised times, the personal touch, the very obvious time and effort you will have spent not only thinking about them, but on their unique gift, exceeds all known value. Their hearts will melt.

Erasers are banned. That business earlier about binning your erasers, and the bin too? That wasn't just frivolity. I'm quite serious.

Keep going. Don't waste time going back to correct mistakes, or else doing a drawing over again.Be the SHARK, always moving forward, on to the next and the next drawing.

Keep all of your drawings, no matter what you might think of them at the time. Buy or make a dedicated folder for them, or have a particular drawer or set of drawers in which to store them.

Keeping all of your drawings, good or bad, gives you a *track record* by which to measure your progress. It also preserves all of your *mistakes*. Mistakes are supremely useful.

Given the chance of *hindsight* you may find the better qualities in even the most wretched-seeming scrawls, and might even end up quite liking some of them, or aspects of them, someplace further down the line.

It takes about *six months* from when they were done for me to be able to accept my own drawings, for me look at and be able to assess them fairly and relatively objectively.

And if even six months later you still don't
like anything of what you see, remember that
it's from your apparent mistakes that you'll
learn the most. They are *object lessons* all
by themselves – what *not* to do, and how *not*
to do it.

If you don't hang on to your drawings, even
if it isn't for the sake of later comparison,
then how will you ever see for yourself how
much you have improved?

Also worth bearing in mind: Many things that started out as mistakes
have gone on to become innovations and new inventions, some more
popular than they would ever otherwise have been (famously, the
recipe for *Coca-Cola* – they were actually looking for a cold cure).

NEGATIVLAND

Still don't like your drawings? The quality of our drawings is too often judged (by the negative self, even more so than by others) based on some misguided traditional ideals.

Culturally speaking, we're oddly hung up on aesthetics of realism or naturalism. This isn't helpful or necessary. It's not even healthy. These ideas are misplaced, and judgements based on the resulting negativity miss the entire point of drawing, behind our making art or even in expressing ourselves.

Why settle for trying to draw 'realistically' (something recognisably representational, or naturalistic)? Instead, be *expressionistic* – indulge in and enjoy the freedom of your unleashed creative self-expression (itself a vital outlet). Or aim for capturing any or all aspects of the moment (*Impressionism*?), the unquantifiable, an otherwise inexpressible quality of life or soul. Look to the act of drawing itself as sufficient (sheer joy/effort/concentration/exercise) – not simply as a means to an end (such as a pleasing picture), but as a worthy end in itself. Live FOR and IN the moment. Fully experience the process, regardless of what you think of the results.

FINDING YOUR WAY/THE WAY BACK

They say, 'First you have to learn the rules, in order that you can break them.' Is this so? *Do* you have to learn the rules in order for you to break them?

Once – most likely in your earliest efforts, when little more than an infant – you would have made all sorts of marks and been entirely, blissfully unselfconscious about it.

Drawing at its best should come directly and instinctively. If it doesn't, then strive to make it so, or simply relax … allow it to become so.

The point of drawing is much more about *expressing yourself* than it is anything else.

LET'S TALK ABOUT **YOUR DRAWING STYLE**
Your individual drawing style comes out of *you*. It should be just as unique as your handwriting, as your fingerprint (ear-print!).

Your style may of course shift and change. But, if you are truly in touch with your hand to eye coordination and the way in which you draw, then these evolutionary changes will most likely be gradual – and trackable.

Your drawings may be controlled, precise.
Or they can be freehand, loose, gestural.
I've spent my life and career learning – being
coerced into learning – how to follow rules
in order to make them more like the first.
Now, my focus is on unlearning all of that.
It's not about breaking rules, but ignoring
them completely if I can – trying to find my
way home, back to drawing being fun again.

At one and the same time it has become my
firmest belief that the very best drawings
are the ones that come instinctively, that
come the most naturally. So that's my
lifelong lesson and my greatest gift to you:

DO WHAT COMES NATURALLY.
**Let your drawings become whatever *they*
want to be, not what *you* need them to be.**

EXPERIMENT. Experiment and *free* yourself.
Experiment and free yourself, to *be* yourself.

Because baby you're a *firework* ...

If you feel you're *struggling* at all, these next pages contain some valuable information and a few wise words (mostly from others).

Otherwise, you're free to skip onward, if you prefer. I do get quite *irate* during it, and I do go on. Or, you could always just look at the boat. It's a nice boat.

Stromsdal, by Jonathan Edwards, www.jonathan-e.com

ART AS THERAPY

We live in a society where creative energy is mostly frustrated. Outside of Fine Art galleries (where the prime interest and key motivation is speculative commercial investment), you'll find most of the Arts and much art practice undervalued, under-funded and, hell, even undermined at a fundamental level.

You can't make a decent living from practising art. Almost any sort of artist's net worth is perceived as being somewhere between that of a cheesemaker and a street sweeper. Don't get me wrong, 'Blessed are the cheesemakers!' – society would soon break down without either. But we don't value or reward our artists compared to, say, stock market analysts or lawyers. We choose not to. It's not *profitable*.

Making *small*-a art has been relegated to little more than a hobby. Yet still, it *is* a very agreeable one. If you can't make art full time then you should still want to make it in your spare time. That's why you, presumably, have bought this book. Furthermore, you should also feel encouraged and *allowed* to!

Unfortunately, having the time to make art remains very much the *preserve* of the idle rich. Alongside these persist a stubborn few, their fringe activities most often ignored or else dismissed as wayward, 'alternative', or just plain crazy. Most commonplace art practice is seen as being entirely without merit – an opinion, almost a credo, that's telegraphed daily from the moment we leave behind the nursery.

KIDS: TUFF

As any primary schoolteacher can tell you, and as every good parent will know, children like drawing. Like? **They** *love* it! So why should that joy, or the habit, have to *go away* once we are grown up?

Has it gone away?

It cannot be underestimated just how *formative* art and play are, amongst our earliest experiences. They guide our first steps towards self-expression ... They're at the very root of communication. And yet, *more* than underestimated, they get forgotten.

In recent years, art in education past the most basic elementary stage is either deemed low priority, or it's *off* the schools curriculum entirely. At best, this is philistine ... at worst, and as a government policy, it's hugely irresponsible. The consequences damage society as a whole, just as they do the individual.

What do we think it means to be a 'grown up'? 'I put away childish things.' (That's in the Bible for heaven's sake!). And then there's the peer pressure to 'toe the line'; bad parenting and worse teaching (faults of distinctly adult neuroses and hang-ups); a gentle push to conform, everyone required to draw in the same way – spiky black suns becoming yellow Smiley badges hovering over little detached houses and gardens (our collective idea of a 'perfect' home, when few people actually live like that). Obsession with high scores, top marks, career prospects ...

All of this steadily conspires until we become overly self-conscious, critical, stunted instead of creative. It can even convince us not to draw any more.

'They can draw, but not me. I can't draw!' Many will have gone through trying, wanting, and ultimately failing (or so they think) to draw as well as the next person. I was lucky, one of the two kids in my school year that everyone else decided 'could' draw.

Now, this book isn't so much about why this should be. Forgive my polemic this far, that's a whole other book. But it *is* a book that seeks to undo at least some of that conditioning, and responsibly so – hoping to turn 'I don't draw' into 'I *can* draw!'

AND HERE'S WHY ...

As adults, moreso than children, we live (trapped, perhaps?) within a highly materialistic, status-oriented and stress-inducing society, one with little to no safety net should you fall between its cracks.

Many people suffer from debilitating psychological and/or emotional trauma without any sort of outlet or adequate means of expression, not least creative ones. If your life is torture, where else do you go?

In my widespread practical workshop experience, prison inmates are among the *best* artists I've met. This suggests a link between frustrated imagination and the so-called 'criminal mind'. Check out their artworks, the work of the Koestler Trust and its associated Awards scheme. www.koestlertrust.org.uk

'Getting creative is essential for the soul and helps us move on with life. What is creativity if it isn't experience conveyed with honesty?'
– *Mat Amp*

'The art table is nearly always the most relaxed table in the hall.'
– *Claudia*, manager, the 240 Project

'The art and the paint and the colours, it's very satisfying, the time and the creation is very valuable. It gives me a breather from burdens and fears, it distracts me and puts me in a better place.'
– *John*, user, the 240 Project, an Arts and Health Activity Centre for people affected by homelessness, vulnerability and exclusion, www.240project.org.uk

'Over the past few years there's been an increased understanding of the positive impact that the arts can have on mental wellbeing ... engaging in the arts ... can help to increase a person's level of motivation, increase self-confidence and self-esteem, and improve concentration, something that can be affected when we're worried or anxious ... you may not be able to express how you feel ... You don't have to be an artist to (paint) or a writer to write.'
– *Christina Clark*, mental health nurse

'So many people tell us that art plays an essential part in their recovery.' – *Pavement* magazine (free to homeless people), www.thepavement.org.uk

Increasingly, the world seems filled with feelings of frustration, impotence, outrage and a lot of anger.

It's no coincidence that there's been a recent and ongoing surge in Adult Colouring Books, wreckable Journals, Doodle whatsits – a whole plethora of such fill-in-the-blank titles.

This isn't *that* sort of soma Activity Book.

Settling for colouring in or otherwise completing somebody else's existing images is merely the coward's refuge. Yes, I said it.

Origination, drawing, mark-making is where it's at – creativity that *creates*, rather than merely adorns. It's properly therapeutic, instead of being just an idle robot pastime.

You have the power to create something *entirely new* that never even existed before you put pen to paper.

The drawing properly allows you to express your *self* and how you are *feeling* …

And what could be more valuable than that?

DOs and DON'Ts

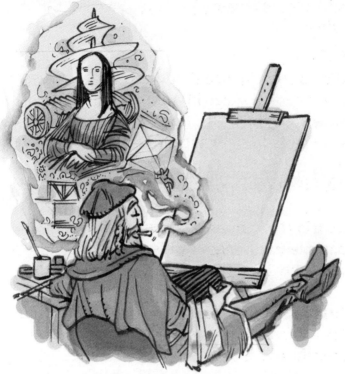

DON'T just dream it – BE it.

DO DRAW EVERY DAY.
Object Lesson – I took an Art Foundation course.
Among my fellow students was one Weem Kareem.
First in, last to leave, I never saw anyone work so
hard, or enjoy it so much. By year's end his artwork
had improved so much he was easily the best of us.

DON'T be lazy, draw like crazy.

DO DRAW MORE – then draw some more.

Find ways to *encourage* yourself. Don't tell, SHOW others your results. Start a blog. Or *Instagram*, etc.

DO Dare To Draw the Everyday …

DO Dare To Draw the Fantastical …

DO stay open-minded to ALL possibilities.

Also, stay OPEN – open *eyes*, open *ears*, open *mind* – DO soak up influence and inspiration from almost *any* source: any*time*, any*place*, any*where*.

DO PLAY TO YOUR STRENGTHS.

But also

DO CHALLENGE YOUR WEAKNESSES.
(Nature AND nurture. Maybe a little Nietzsche even.)

DO LEARN FROM YOUR IDOLS.

But also

DO OUTGROW YOUR INFLUENCES.

DO ULTIMATELY GO YOUR *OWN* WAY.

DON'T LISTEN TO THE (negative) VOICES.

DON'T ERASE.

I'll say it again ...
DON'T RUB ANYTHING OUT.
(**DO** instead work on *through* it.)

DON'T THROW ANYTHING AWAY.
(**DO** learn from your mistakes. Bear witness
to your own progress.)

DON'T SAY 'I can't draw' especially when
what you mean is, 'I **don't** draw.'

DON'T SAY that either.

This is (re)solved by reframing, through the
simple ACT of drawing. Feel the fear but **DO**
it anyway. (Free your mind and your, um,
drawing will surely follow.)

DO GET OUT OF YOUR OWN WAY.

DO! JUST DRAW!!

Everybody PUMP YOUR PENCIL like this ...

... DON'T STOP, DON'T QUIT. Just DO it, DO it, DO it, DO it, DO it NOW, Make it GOOD.

DO concern yourself with the ACTIVITY, the action, and not so much the results. It's the DOING that's the important part – less so, appeasing your critical self (the naysayer).

DO DO the GRITTY INTEGRITY thing ...

Learn to draw like YOU.

Learn to LIKE your drawing.

'**Whatever is, is right.**' – *Alexander Pope*

DO ALWAYS SIGN IT.
(Take the credit, or the blame.)

How to Draw Absolutely Anything

SKETCHING PAGES